WITHDRAWN

Pratt and Its Gallery

and Its

THE ARTS & CRAFTS YEARS

An exhibition of paintings, drawings,
photographs and decorative arts
representative of works shown at the
Pratt Gallery during its critical first
decade, 1894–1904.

Curated by Marsha Morton

Published in conjunction with the exhibition
Pratt and Its Gallery: The Arts and Crafts Years

September 18–October 27, 1998
Jensen Fine Arts
4 East 77th Street
New York, NY

November 13–December 19, 1998
The Rubelle & Norman Schafler Gallery
Pratt Institute
200 Willoughby Avenue
Brooklyn, NY

This exhibition and catalogue were made possible,
in part, with support from the Henry Luce Foundation,
the Edith C. Blum Foundation, and the Julie Pratt Shattuck
Charitable Lead Trust.

ISBN 0-9708440-1-8
Library of Congress Control Number: 2001130114

Design: Marta Willett, J. Dorian Angello, Elizabeth Bristow
Art Director: Lee Willett
Production Manager: Elizabeth Bristow
Photography of art works: Dorothy Zeidmann *unless
otherwise noted*

Foreword

Although I've long known that a gallery once existed in the Pratt Library, I was astonished when Marsha Morton informed me that this gallery boasted an ambitious and well recognized exhibitions program during the 1890s, soon after the founding of the Institute itself. Thanks to her research in the Pratt Archives and at many other institutions, the "Pratt connection" to the art world of turn-of-the-century New York, often overlooked by other scholars, has once again been revealed. This exhibition, comprising art works representative of those shown in the original Pratt gallery between 1894 and 1904, is far more than a simple survey. Drawing on a wide-ranging grasp of aesthetics, educational theory and social history, Professor Morton traced the origins and evolution of the Institute's pedagogical mission and the gallery's role in implementing that mission. With great insight, she illuminated Pratt's ties with leading artists of the day and with the Arts and Crafts movement.

I am grateful to Marsha Morton not only for her inspiring scholarship, but even more for her enthusiasm, humor and flexibility throughout the long months of preparation, and I will remember our collaboration as one of the most rewarding of my years at Pratt.

Gallery Registrar Nicholas Battis and Exhibit Designer Katherine Davis are accustomed to meeting new challenges for every major curated exhibition. However, this historical show required extraordinary effort over a long period of time, and I am indebted to them for their unfailing cooperation and understanding. Equally, my heartfelt gratitude goes to our collaborators Diane McManus Jensen, Anne-Marie Belli and Carol Sattler of Jensen Fine Arts who hosted the exhibition in their magnificent gallery and lent their considerable expertise to the installation, publicity and events.

On behalf of Pratt, I want to thank the Henry Luce Foundation, the Edith C. Blum Foundation and the Julie Pratt Shattuck Charitable Lead Trust for the confidence and support they invested in this exhibition and catalogue long before they materialized.

Eleanor Moretta
Director of Exhibitions

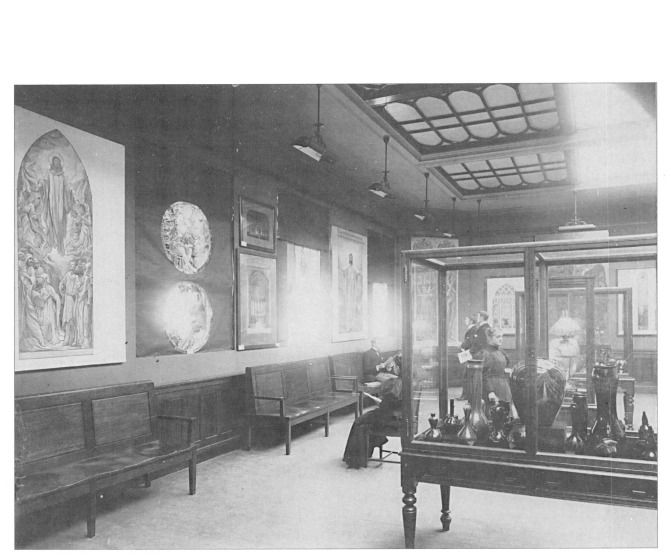

Tiffany glass exhibition in
the Pratt Gallery, March 1897

Acknowledgements

This exhibition and book have succeeded, despite considerable obstacles, because of the support and assistance of many individuals. I am extremely indebted to many colleagues at Pratt Institute who have generously shared their time and ideas. Foremost among these are Library staff members Dean F. William Chickering, Greta Earnest, Joy Kestenbaum, Sydney Starr and, especially, archivist Margot Karp, who tended Pratt's historical records for years before I ever learned of their existence. I am also deeply appreciative of the encouragement shown by all members of the Art History department, though special thanks go to Diana Gisolfi, Pat Sands and Jennifer Brundage. Vivien Knussi, in particular, provided invaluable assistance through her knowledge of American art, her extensive contacts in the gallery world, and her friendship. The administration at Pratt was equally supportive, and I am grateful for the commitment shown this project by former Provost Ed Colker, Vice President Mack Goode and Dow-enthusiast President Tom Schutte.

I am also indebted to the generosity of the many lenders to the show and especially to the cooperation and interest of the staff of the Brooklyn Museum of Art. This exhibition would have been difficult to realize without the participation of curators Amy Poster, Kevin Stayton, Diana Fane, Linda Ferber and Marilyn Kushner. The completion of my research was in large measure due to the kind assistance of numerous individuals who graciously shared their time and knowledge. These have included the symposium participants Frederick Moffatt, Julia Meech, Barbara Michaels and Linda Ferber, and also Diane Fisher, Joseph Maschek, Stephanie Gaskins, Barbara Livesey, Jane Egan, Erin Gray, Nancy Green, Melinda Boyd Parsons, Betty Krulik, Jonathan Harding, Ronald Pisano, Robert Cestone, Kaycee Benton, Bailey Van Hook, Rachel Stern, Amy Brook Snider, Beverly Warmath, Walt Read, Harry Katz, Bonnie Yochelson, and Roy Pedersen. I also owe special thanks to Barbara Wright who welcomed me into her home and brought Dow's spirit alive.

Finally, the contributions of Pratt Exhibitions staff Nicholas Battis and Katherine Davis, and student research assistants Matthew Delegett, Kim Piotrowski, Maiko Ota, Amelia Cox and Paul Flippen were essential to the success of this undertaking. I am, however, most indebted to the tireless efforts, commitment and camaraderie of Eleanor Moretta, Director of Exhibitions, without whom the exhibition would never have been completed.

Marsha Morton, Ph.D.
Associate Professor of Art History
Exhibition curator

FOUNDER'S DAY NUMBER.

Pratt Institute Monthly

OCTOBER, 1892.

VOL I

NO I

PUBLISHED BY PRATT INSTITUTE BROOKLYN, N.Y.

Pratt Institute Monthly,
Masthead of the first issue

Missionaries of Culture

The riches of the commonwealth
Are free strong minds and hearts of health,
And more to her than gold or grain
The cunning hand and cultured brain.

With the above epigraph the *Pratt Institute Monthly* launched its inaugural issue in October 1892. Noting that they were beginning publication on the founder's birthday, the editors observed that it was "like being born under a lucky star." Their purpose was "to keep the *Monthly* human, interesting, and alive. It will never preach unless so attractively that the berated will not recognize it."[1] These sentiments vividly capture the spirit of the young school—energetic, enthusiastic, and idealistic.

Pratt was indeed "born under a lucky star." Begun by Charles Pratt in the fall of 1887 with much conviction but little long-range planning, the school's rise was meteoric. The original twelve students grew to 3,000 by 1891 representing twenty different states.[2] Within one year of its opening, Pratt was praised by Andrew Carnegie and featured in an extensive *Scientific American* article where it was described as "the most important enterprise of the kind in the country, if not the world."[3] In 1893 Baedeker's travel guide pronounced it "one of the best equipped technical institutions in the world."[4] During the same year art department statisticians calculated that the sixty-two employed graduates from the Normal School (for teacher-training) were now supervising and instructing 4,957 art teachers throughout the country who had in their classrooms 245,197 children.[5]

Pratt owed much of its success to timing, as well as talent. Founded during an age of rapid growth in art institutions, it was perfectly positioned to benefit from the burgeoning economy, despite the recession of the early 1890s, by offering cures for societal problems that industrialization had created. Pratt faculty and students were fully committed to a mission of social reform through beauty in art. In an era of class inequality, poverty, urban crime and labor disputes—all topics addressed in articles in the *Pratt Institute Monthly* and by guest lecturers—the Pratt community, like-

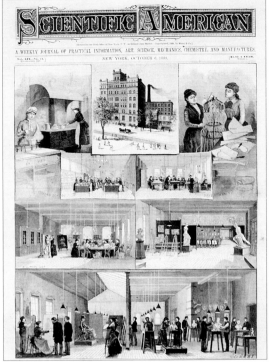

Pratt Institute, as illustrated on the cover of *Scientific American*, Volume L, Number 14, October 1888.

many others in the Arts and Crafts movement, believed in the morally redemptive power of beautiful well-made objects. The experience of "feeling beauty" would "refine actions" and "rebuke selfishness and unkindness." An editorial in the *Monthly* stated: "awaken the power of beauty, by education, in all minds, and the world will quickly become a brotherhood…. Each student…will become an individual reformer."[6] Accordingly, Pratt's efforts in all areas aimed at democratizing art; the studio and workshop were to be united in their production of art accessible to everyone.

Manual Training and the Foundation of Pratt Institute

CHARLES PRATT'S ORIGINS were humble.[7] Born in Watertown, Massachusetts on October 2, 1830, Pratt was the seventh of eleven children. He left home at age ten to work first on a farm and then in a Boston grocery store, after which he became apprenticed to a machinist in Newton. He pieced together an education through one year at Wesleyan Academy in Wilbraham and many hours spent reading in the Mercantile Library in Boston. In 1851 he arrived in New York where he worked his way up from clerk to partner in an oil, paint and glass business. By 1867 he had founded the Pratt Manufacturing Company in Williamsburg which produced "Astral Oil," an illuminating oil unrivaled for safety because of its resistance to combustion. Together with several other major refiners, Pratt merged privately with John D. Rockefeller's Standard Oil in 1874; their alliance was publicly announced in 1882 with the signing of the Standard Oil Trust agreement.

By that time Pratt was thoroughly preoccupied with plans for his future school. His motivations, explained in response to an inquiry from Isaac Edwards Clarke for his U.S. government sponsored survey on industrial education, were to "do something for young people situated as I had been."[8] His goal was to make Pratt Institute a model for "experimental work of this kind of education."[9] Pratt devoted several years to visiting American and European schools, studying curricular programs at Cooper Union, the Peabody Institute and Girard College, and interviewing leading educators including Felix Adler, John D. Runkel, Calvin M. Woodward (manual training experts), Enoch Pratt (Baltimore philanthropist), and Susan Blow, who had established the first American public kindergarten in St. Louis in 1873.[10] Nonetheless, he embarked on his project with much hesitation, reporting to Clarke that "I had theorized for many years as to the kind of scheme I would like to work out, but did not see the way clear to its organization and management."[11] Pratt's indecision would prove to be an asset in the coming years, facilitating the innovation and diversity that would characterize school policy during the next decade. Clarke noted this feature approvingly in his discussion of the Articles of Incorporation (May 1887), observing that "no hard and fast lines or limits are established. The Trustees of this Institution…are wisely left with full liberty to change, modify or enlarge

the plans, methods and courses of instruction, in such ways…as the changing circumstances of coming years may make desirable."[12]

Pratt's plans remained cloaked in secrecy even while construction began, with the Romanesque Revival building by Lamb & Rich designed to be converted to a factory if the school failed. The sober character of the architecture embodied Pratt's pragmatic goals of providing educational training and job skills for individuals, especially immigrants, with few economic advantages. As stated in the Articles of Incorporation, his objectives were:

> …to establish in the city of Brooklyn an educational institution in which persons of both sexes may be taught, among other things, such branches of useful and practical knowledge as are not now generally taught in the public and private schools of said city. The special aim shall be to afford opportunities for persons of both sexes to become acquainted with what is best in manufactured materials, fabrics, wares and arts, and…to educate the eye and hand in the practical use of tools and machinery.[13]

At the same time, the incorporation act also provided for a free public circulating library and reading room, a gallery of art and science with a collection of objects, and lectures to "promote mental improvement." These features marked an advance over Cooper Union, founded in 1859, whose library was not circulating and whose museum was not begun until 1897.[14] They also reflected essential components of the Institute's pedagogical philosophy which was based on the principles of manual training, the most recent innovation in industrial education. This movement, begun in the late 1870s by John D. Runkle at the Massachusetts Institute of Technology and Calvin M. Woodward in St. Louis, was increasingly in the forefront of debates with supporters lobbying for its incorporation in public secondary schools.[15] Among the most impassioned advocates was Pratt's friend Felix Adler, who founded the first kindergarten in Brooklyn (1878) and the Workingman's School (1880), which extended instruction through the ele-

mentary school level. Both were opened under the auspices of the New York Society for Ethical Culture, established in 1876.[16]

Manual training involved object-based learning in workshops with scientific study. Emphasis was placed on mental growth in conjunction with teaching technical skills. Promoters believed that intellect and character could be developed through drawing and constructing objects (honing powers of perception, observation and judgment) and by recognizing elements of beauty. Students were always to be taught the principles behind their work. The pedagogical basis for manual training, as noted in articles by Pratt faculty members, was

Main Building and Ryerson Street in the 1890s.

found in educational theories of sense perception derived from Jean-Jacques Rousseau, Johann Heinrich Pestalozzi and Friedrich Froebel, the founder of the kindergarten movement. Froebel advocated teaching the "whole individual" (physical, mental and spiritual) by exercises stimulating the imagination through "self-activity."[17] Like the Arts and Crafts movement, whose growth it paralleled, manual training was also indebted to the philosophical views of John Ruskin, who deplored the dehumanizing effects of industrialization and preached the morally beneficent results of reuniting art, labor and intellect. Ruskin, whom Charles Pratt was fond of paraphrasing, proclaimed, "It is

only by labor that thought can be made healthy, and only by thought that labor can be made happy, and the two cannot be separated with impunity. It would be well if all of us were good handicraftmen in some kind, and the dishonour of manual labor done away with altogether."[18] By comparison, Pratt identified one of the aims of his school as being "an appreciation of the dignity as well as the value of intelligent handicraft and skilled manual labor."[19] Appropriately, Pratt opened its doors for business one month after the first celebration of Labor Day.

Manual training was still controversial during the late 1880s. In addition to the schools mentioned above, curriculums based on the new theories were begun in New York at the Oswego State Normal Schools and, during the 1890s, at Syracuse University, Columbia Teacher's College and the Rochester Athenaeum and Mechanics Institute.[20] Through Charles Leland, Philadelphia was one of the first cities to introduce manual training in public schools in 1880. New York State passed a bill in 1888 authorizing the establishment of manual training departments in secondary schools.[21] Pratt not only based many of its teaching principles in art and design on manual training, but also founded a Technical High School and Kindergarten in 1889, offering a unique comprehensive educational package from pre-school to the post-secondary level. At that time, no public secondary school in Brooklyn provided manual training. Lecturers at Pratt featured advocates of the new methodologies including Woodward (1891), Jane Addams (1898), and Kate Douglas Wiggin (1891).

Compared to other industrial art schools, however, Pratt went further in integrating technical instruction with academics and emphasizing the development of moral character. Pratt's seal displayed four areas of specialization: science, literature, labor, and art. These goals were clearly stated in the first catalogue of 1888:

It is now generally recognized that manual training is an important and necessary adjunct to the education of the schools, and that mind and eye and hand must together be trained in order to secure symmetrical development. Manual training aims at the broadest, most liberal education. While developing and strengthening the physical powers, it also renders more active and acute the intellectual faculties, thus enabling the pupil to acquire with greater readiness, and to use more advantageously, the literary education which should go hand in hand with the manual.

It [Pratt] endeavors to give opportunities for complete and harmonious education, seeking at the same time to establish a system of instruction whereby habits of thrift may be inculcated, to develop those qualities which produce a spirit of self-reliance, and to teach that personal character is of greater consequence than material productions.[22]

Charles Pratt soon put these words into practice by establishing the Thrift Association, based on the Birkbeck Society in England, which was a campus "savings bank" for students to learn money management. They were also provided with opportunities to practice community service through the Neighborship Association, a settlement house founded by Pratt in Greenpoint near the Astral Apartments built for his factory workers. This Association, which facilitated the practical application of social reform ideals preached at the school, offered arts and crafts classes, sewing instruction, lectures, and a gym and library for neighborhood families. Reports on their activities appeared in the *Pratt Institute Monthly* together with articles on related topics including Hull House in Chicago, Toynbee Hall in London, University Settlement in Manhattan, and essays by Jacob Riis on tenement house conditions and urban poverty. Both Riis and Jane Addams spoke at Pratt, where lectures were frequently given on topics of moral and social issues. A series from the spring of 1893, for example, featured talks on "Self-supporting Women,"

"Social Ethics," "Home and Society," and "Is American Society Tending to the Overestimate of Wealth and Position?"[23]

The intentions of Charles Pratt, who repeatedly extolled the value of the workman over the machine, echoed those of Harvard president Charles W. Eliot, another proponent of manual training, and sharply distinguished the Institute from other schools.[24] According to Richard Boone in his 1889 survey, *Education in the United States,* thirty-seven schools for art and/or design were in operation.[25] Training in these areas, however, was largely separate until the late nineteenth century, with design schools serving the commercial interests of manufacturers. Aspiring artists studied at academies modeled on the French *École des Beaux Arts* with a curriculum based exclusively on drawing and painting from casts and life. The most prestigious were the Pennsylvania Academy of Fine Arts (founded in 1807), the National Academy of Design (1826), and the recent "secessionist" school of 1875, the Art Students League. Students seeking training in the industrial arts attended vocational schools, polytechnics, or mechanics institutes, which had replaced the earlier apprentice system. These provided minimal theoretical education. By the 1870s new integrations of art and design training began appearing at the recently created art school-museum affiliations.[26] While these generally offered a limited selection of classes organized around copying works in the collection, they began to integrate design courses such as mechanical drawing, woodcarving and textiles. The many museums and schools which date from this period include the Pennsylvania Museum and School of Industrial Arts (1875), the School of the Museum of Fine Arts, Boston (1876; the museum was founded in 1870), the School of the Art Institute of Chicago (1879), the St. Louis School and Museum of Fine Arts (1875), and the Buffalo Fine Arts Academy (1876). Many of these institutions, as well as their design classes, were created in response to the poor showing of American products at the 1876

Philadelphia Centennial and were financed by wealthy manufacturers. The Centennial displays also accelerated the adoption of manual arts programs in elementary and secondary schools. Most turned to the British South Kensington Schools and Museum (the Victoria and Albert) for solutions. In England designers were educated apart from the academy through a system devised by Henry Cole in the 1850s. Students developed technical proficiency by copying prints of stylized symmetrical ornaments whose geometric basis facilitated easy mechanical duplication. The Museum assisted by exhibiting exemplary decorative arts from the past for inspiration. This marriage of art, commerce, and education typified the era and undergirded art schools like Pratt as well as museums. The charter for the Metropolitan Museum of Art (1870) listed one of the institution's functions as the "application of arts to manufacturers and practical life," while the motto on the seal of the Boston Museum of Fine Arts proclaimed "Art/Education/Industry."

The South Kensington School model spread quickly in this country following its adoption in Massachusetts where the subject of drawing in public schools was first mandated by law in 1870 in response to petitions from merchants and manufacturers. Walter Smith, a graduate of South Kensington, was hired as the Massachusetts State Art Director. His system of industrial drawing—which stressed geometric structure as the key to developing the "faculty of imitation"—was disseminated throughout the country beginning in 1873 when he became the founder and director of the Massachusetts Normal Art School.[27] The Smith/Kensington approach to drawing was implemented at the Woman's Art School of Cooper-Union under the leadership of Ellen Childe and Susan Carter during the 1870s.[28] Cooper-Union, whose night school prepared men for jobs in the machine trades, architecture and engineering, taught women art as practical design "for useful employment." Most studied the applied arts or prepared to be teachers;

students who wished to pursue professional fine arts training were referred elsewhere. Likewise, the Rhode Island School of Design (1877), founded by a consortium of Rhode Island industrialists, was created to train designers for "trade and manufacture" using the South Kensington model. In actual practice, a fine arts curriculum evolved at the school which also opened the Waterman Galleries in 1897.[29] Both Cooper-Union and R.I.S.D. had a two-track system with women in the daytime art school (although at Rhode Island the pupils were ladies of "independent" means) and men preparing for industrial jobs at night.

While both Pratt and R.I.S.D. grappled with the dialectics of fine arts versus technical instruction, Pratt was different from its competitors because of the manual training philosophy. That movement, following the lead of Ruskin, had arisen in opposition to the South Kensington policy of learning by copying, to the belief that designers should be trained according to the skill-based needs of manufacturers for commercial profit, and to the perceived dehumanizing process of factory work. During the 1890s tensions occasionally surfaced at Pratt in an attempt to devise a curriculum that balanced employment realities with creativity and aesthetics. Until 1904, however, the scale was heavily weighted on the side of the latter consideration. All of the faculty, most of whom had studied at the Massachusetts Normal School, were firmly against the South Kensington system, described by J. Frederick Hopkins (teacher of industrial drawing and director of the museum) as "the servile rendering of flat copies upon the pages of textbooks."[30] Walter Perry criticized British products in the Chicago World's Fair as "conventional, and lacking in freedom." He observed, "The cause lies in the fact that everything emanates from one authority, the 'South Kensington Art School.' There is little opportunity…to show individuality."[31]

Curricular Growth

ISAAC CLARKE CATEGORIZED Pratt as an "eclectic" institution, and its growth during the early years proceeded in a somewhat haphazard manner, responding to opportunities as they presented themselves. Nonetheless, as will be seen, the school successfully diversified while retaining a comprehensive pedagogical philosophy and mission. The first department established by Charles Pratt was the Department of Drawing (listed as the School of Art and Design in the 1888–89 catalogue) under the direction of Walter Perry, who was hired during the spring of 1887 before building construction was completed. Perry had studied at the Massachusetts Normal Art School, and was employed as the supervisor of drawing for the Worcester public schools. He frequently wrote and lectured on art education. Perry was also affiliated with the Prang Educational Company which published his essay, "The Teaching of Drawing in Public Schools" in 1882.[32]

The School of Art and Design initially offered courses only in drawing, but, in an era which viewed the acquisition of drawing skills as the path to social betterment, these were seen as the linchpin of the new school.[33] The first catalogue proclaimed: "Drawing is fundamental; it is the basis of all the constructive industries, all pictorial art and decorative design…. It is the one universal language, and its importance to the designer and artisan is only comparable with reading and writing."[34] The curriculum was organized into three levels, beginning with freehand drawing and progressing to painting from life. Specialized courses were also provided in the areas of design, architectural and mechanical drawing, clay-modeling, and woodcarving, thereby serving as the central hub of the school for all students requiring drawing instruction. The other departments included Domestic Science, Mechanic Arts, Building Trades, Shorthand, and the "Regular Three Years' Courses for Boys and Girls" which soon became the Technical

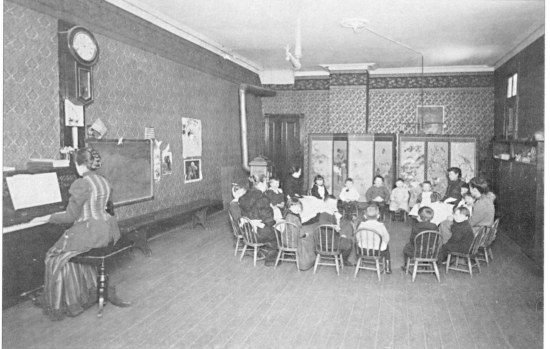

Above: Art school faculty with Frederic Pratt (center), 1890s.

Left: Pratt kindergarten class, 1890s. Kindergarten students absorb the aesthetic benefits of good design as they play in a room decorated with Japanese screens and prints of Raphael paintings.

High School. Additional services were provided by the Library and Reading Room, the Technical Museum, and the lecture series (on topics pertaining to "right modes of living, the problems of political and social life, domestic economy, sanitary science, literary culture, ethics, etc."). The ambitious scope of the programs inspired one newspaper reporter to quip "Pig Iron and Pastry: Both are Handled at the Pratt Institute."[35]

Expansions and alterations proliferated during the next few years. New additions included a short-lived Department of Music (1888–1893), Kindergarten (1889), and Saturday Morning School for children in sewing (1893) and art (1894). The "shorthand" department soon evolved into the School of Commerce and established itself independently of Pratt in the fall of 1895. In response to requests from other institutions, library training classes began in 1891 leading to the Library School in 1893, and teacher-training courses were introduced in Art and Design (the Normal School), Kindergarten, Domestic Art and Science, and Manual Training. Other curricular changes were even more directly driven by the marketplace. New courses in tinsmithing and weaving were added by Charles Pratt in response to requests from manufacturers, while he was persuaded by the Painters and Decorators' Association to offer fresco and mural painting classes in 1890. Spanish was added in the School of Commerce in 1892 because of improving trade relations with Central and South America.[36] Most departments went through multiple name changes, reflecting conceptual shifts. In 1892, for example, the Department of Mechanic Arts, chaired by Charles Richards, became the Department of Science and Technology because "there is no trade that is not scientific and technical...*why* precedes *how* every time."[37] The Technical High School soon dropped the "technical," as well as the reference to "manual." Perry found those adjectives too redolent of "hand and mechanical training," whereas "the subject is far broader than that."[38]

By far the largest department was Domestic Science, whose enrollment numbered 2,817 during 1890–91, leading to its division into Domestic Art and Science in the fall of 1892. These programs, customarily viewed as the "female" component to manual training, were conceived by Charles Pratt to assist homemakers in "household economy and home management" as well as to train women for careers. The increasingly central role assigned to women by the Arts and Crafts movement in creating aesthetic environments integrating art and daily life contributed to the success of these departments. Indeed, Pratt was uniquely equipped among art schools to implement all aspects of Arts and Crafts ideology from training artisans to offering instruction in decorating the home. The growth of housekeeping as a "scientific" pursuit based on studies of hygiene also fuelled enrollment. Throughout the 1890s the Department of Domestic Science became more oriented to preparation for professional careers, with degrees for dieticians and home nurses offered at the end of the decade. By 1893 required courses included German, physics, chemistry, biology, and bacteriology. A three-month class was even offered in the history and theory of laundry. Domestic Arts introduced one of the first programs in costume design in 1898 and contributed frequent articles in the *Pratt Institute Monthly* on the history of fashion. Both departments also sponsored their own series of exhibitions and lectures.

Pratt at the Chicago World's Fair

DISPLAYS OF WORK from all the departments attracted attention and praise at the 1893 Chicago Columbian Exposition which served as a measuring stick for the young school. Extensive administrative time was devoted to transporting and installing the exhibits in the Department of Liberal Arts on the second floor of the Manufacturer's Building, and the efforts were gratifying. Hopkins, who supervised the undertaking, reported that most of the visitors were already aware of Pratt:

When one meets in this connection, in the period of a few days, an educator from the Malay peninsula—a director of a prominent school in Geneva—a German professor—a French commissioner—an English expert—a commissioner from South America—the professor of a Japanese University and a lecturer from far away Australia, and finds that almost all knew of Pratt Institute and could say little but praise for its efforts, then it is that one realizes how the knowledge of the courageous effort of one man has gone abroad and is appreciated.[39]

Pratt gained further publicity when many of these international educators visited the school before returning home.[40] Positive assessments of Pratt also came from less biased sources. An article in *The Arts* reported that Pratt's "exhibit at Chicago attracted much attention, and yet, in direct competition with the schools of that city and New York, this school began its work in Brooklyn only six years ago."[41]

Pratt received additional exposure through the participation of faculty members Charles Richards and Walter Perry as speakers at the Congress on Manual and Art Education. For those who couldn't attend, the *Monthly* published the lectures together with a detailed illustrated description of the exhibits and a review by Perry. He interpreted the World's Fair as a triumph for American art, and predicted: "The year 1876 [the Philadelphia Centennial] marked the great turning-point in industrial products. An appreciation by the American people of architecture, sculpture, and painting combined, will date from the year 1893."[42] Art exhibited at the Columbian Exposition would help shape aesthetic trends over the next decade. Much of the work shown in the Pratt Gallery during the 1890s reflected trends established in Chicago. These included displays of Native American baskets and blankets, Japanese objects, and paintings and drawings by American muralists and illustrators.

The presence of women in art was also conspicuous at the Exposition and heralded their role in the developing Arts and Crafts movement. The World's Fair included a Woman's Building filled with international displays of fine arts, handicrafts, and industrial art by contributors as diverse as Queen Victoria and Mary Cassatt. According to an article in the *Pratt Institute Monthly,* "there is no one building on the grounds which excites more curiosity and attracts more visitors than this."[43] In conjunction with the exhibition, a Congress of Women was held under the sponsorship of the Department of Woman's Progress, with more than two hundred women participating.[44] Feminism also flourished at Pratt where the majority of the student body—and many faculty members—were women. The Graduate Association of Women, an alumnae group formed in 1892, organized an exhibit of work by faculty and graduates which was installed on the first floor of the Woman's Building at the Exposition and was awarded a medal.[45] A notice in the *Pratt Institute Monthly* proclaimed, "This is the woman's era, and the Nineteenth Century ought not to close without the organization of women workers. The first step taken by the association toward this ultimate aim is the exhibit it is preparing for the World's Fair Woman's Building."[46] Attitudes like these, as well as innovative curricular strategies, earned Pratt a reputation as a "headquarters for liberal thought and advanced movements."[47]

Gender equality in admissions was stipulated in the Articles of Incorporation, and subsequent catalogues pointedly stated: "both sexes are admitted on equal footing to the privileges of the Institute."[48] Pratt opened the first public swimming pool in Brooklyn to include women in 1897 and sponsored a girl's basketball team. While most women were enrolled in the Department of Domestic Science and Art, Library School and the Normal School, a few studied in Science and Technology or Building Trades. An article in the *New York Recorder* (February 12, 1893) was titled, "The Female Carpenter: She Works with Men at Pratt Institute." Lectures and articles in the *Monthly* frequently appeared on topics of women's rights in education and business.[49] Many of the

editors of the magazine were female faculty members. Early organizers included Mary Wright Plummer, Madge Healy (both from the Library) and the registrar Mary White Ovington. Ironically, given the frequent mention of gender wage disparity in the *Monthly* articles, Pratt salaries for women remained far below those of men.[50]

Training the Eye and the Mind

THE ACADEMIC DIVERSITY at Pratt was striking, as a glance through the *Pratt Institute Monthly* reveals, where an article on the psychology of pockets could be found next to a study of Roentgen's x-rays, an investigation of manual training in Central Africa, an essay on Froebel's techniques in Japanese schools, a report on Monet and Giverny, and a review of the 1896 Olympics in Greece. Nonetheless, a unified educational philosophy and mission emerged and became increasingly evident in new directions taken after the sudden death of Charles Pratt in May 1891. Leadership of the school was now transferred to his son Frederic who had been assisting his father since his graduation from Amherst College in 1888.[51] Frederic Pratt, who would be instrumental in setting policy and implementing change, characterized the "law of growth at the Institute" as "diversity in unity" based on departmental interrelationships.[52] Hopkins reiterated this opinion in an article published in 1895: "The most striking feature of the Institute is its unity. A oneness of purpose, of ideas, and of methods binds the departments of this great school into a more harmonious relationship than exists in most other institutions."[53] The "unified purpose" to which the school dedicated itself was the integration of the fine and applied arts facilitated by training the craftsman as an artist. An editorial in the 1892 inaugural issue of the *Monthly* succinctly stated these goals while explaining reasons for changing the name of the Art Department (the title used since 1890):

Henceforth it will be known as the Department of Industrial and Fine Arts, which more directly conveys the central thought of the trustees that the distinction between the fine and applied arts should be forgotten, and an endeavor made to bring back beauty to its legitimate economic relations. This, translated, means that beauty can be taught in the shops as well as in the studios, that it can enter into the making of doors, boxes, and chairs, in no less a degree than into that of statues and pictures. The day will come when beautiful pots and kettles will not excite laughter.[54]

More than aesthetics were at stake, however. Taking their cue from Ruskin's belief that "to teach taste is to form character," Pratt faculty viewed their educational role as a larger mission for shaping moral and social reform through the therapeutic powers of beauty. Another editorial in the school journal compared Froebel's theories with those of the German Enlightenment critic Gotthold Ephraim Lessing, who stated, "it was the belief of the Greeks that beauty in the things beheld produced beauty in the beholder." On this basis, the editorial writer described "the production of beauty in every form" as "a matter of universal importance," achievable only "if the artisan of today were an artist, as in times gone by." He concluded: "All that is needed is that the artisan should himself know beauty and have the instinct for it in himself. Machines for mechanical uses, but the hand, guided by the soul, for art. Nothing else will deliver us from our commonness."[55] Accordingly, throughout the 1890s, Pratt would shed its image as a trade school in exchange for an art and design orientation.

Education for artists and craftsmen was integrated through core courses taken during the first year and shared pedagogic methods implemented throughout the school aimed at developing the student's creativity and individuality. Based on principles of Pestalozzi and Froebel equating education with growth through self-activity, and on manual

training objectives of character development through handwork, Pratt faculty sought to cultivate perception and judgment instead of implanting factual or technical information. Charles Richards adopted the concept "power, not knowledge" from Charles Eliot as the credo of the school.[56] Richards' emphasis on instruction which stimulates individual thought and incorporates theoretical principles was pervasive throughout the High School, the Departments of Domestic Science and Art, and Science and Technology. He wrote: "The attempt to impart information is succeeded by the endeavor to develop the strongest and most harmonious character in the individual. The critical question is no longer how many facts of grammar, or history, or mathematics, has the pupil obtained in his school course, but how fully have his powers of perception and reasoning and expression been developed."[57]

In the art department this philosophy resulted in efforts to nurture the student's creative abilities and his powers of aesthetic judgment through a sensitivity to beauty. The goal of "individuality" was repeatedly invoked in Founder's Day addresses and department reports. Hopkins echoed Richards when he wrote, "education in its broadest sense is conceived to mean the training of the mind to see, to think, and to act; to the development of power, and not to the slavish working out of tasks. It means the bringing of broadening influences to bear upon the mind."[58] Walter Perry defined art as an expression of thought, rather than merely a technical ability to visually reproduce facts. For him, an educational policy based on the theories of Pestalozzi and Froebel harmonized with his own dislike of "coarse" realism in painting.[59] In an 1893 article, "Art Education in the Schools," Perry linked his Hegelian idealism with the theme of "power, not knowledge":

> We are not to teach children simply to do things, but lead them to acquire power in wise discrimination, remembering always that it is not the results that are to be looked for, but rather the creation of a power within the pupil

to exercise correct judgement. [It is the educator's task to] create within [the student] a power for original observation and investigation, and in his expression of what he sees, he must represent more than facts.... It is only when expression becomes idealized and partakes of the spiritual forces within, that it rises above facts and renders prose into poetry.[60]

"Correct judgement" of beauty involved faculties of sense perception—consistent with Rousseau's pedagogy—rather than analysis. Perry discerned beauty in simplicity and utility, in accordance with an Arts and Crafts perspective. Students must be taught to design objects with "good proportion, good outline, and fitness to use." This would only happen when they were "able to *feel* beauty of form," [emphasis added] rather than mechanically "analyze and…accurately produce certain arithmetical proportions."[61] In the opinion of Perry and Hopkins, however, these "feelings" were not innate, but needed to be developed through exposure to instructive examples. Perry observed that "unfortunately, great and true works of art are not attractive to the mass of people…they prefer common, everyday scenes, which do not express a single idea."[62] Hopkins wrote to Frederic Pratt: "I find that to the average observer certain of the 'old masters' present more features for ridicule than for appreciation. One must have considerable training to have a sufficiently broad mind to appreciate certain of the historic pictures; only to the cultured students are their glories real."[63]

For both men the educational mission of Pratt was to cultivate in the student an awareness of beauty as embodied in canonical masterpieces of Western fine and applied art and architecture. Increasingly, Japanese design would also be presented as the cynosure of beauty. Through these objectives Pratt allied itself with the growing "art world support structure" discussed by H. Wayne Morgan and Sarah Burns which included critics, galleries, museums, clubs, magazines and advertisers who sought to "elevate" public taste and create an audience receptive to art.[64]

Hopkins' and Perry's goal, an integral component of the overall institutional shift during the early 1890s from the mechanical to the aesthetic, was pursued through Perry's art history lectures and the expansion of the Technical Museum's collection into photographic reproductions and casts. Directions taken by the museum would also establish the foundation for the gallery. This new orientation was additionally encouraged in reports by John Spencer Clark to Charles M. Pratt in 1893. Clark, treasurer and business manager of the Prang Educational Company and co-author with Perry and Mary Dana Hicks of the *Teacher's Manual,* had been asked to provide a "strategic plan" for the future growth of the school. Clark's recommendation was to enhance the "intellectual or culture" side of Pratt.[65] He argued that Pratt could distinguish itself from other similar schools by providing instruction of "a broader character than that of mere technical instruction."[66] His suggestion was to establish a central department of history to service all the subjects taught at Pratt. Clark also offered opinions which led to the creation of a gallery for contemporary art and to the hiring of prominent artists as faculty. His report concluded: "By strengthening the Art Department, by identifying with it some of the best artists (as I understand is contemplated,) by...public lectures on the relation of the Art idea to history, to education and to daily life, the Institute would soon have a clearly recognized leadership in one of the most important educational movements of the age."[67]

The Technical Museum and Gallery

THE BASIS OF THE COLLECTION in the Technical Museum, located originally on the fifth floor of Main Building, was acquired in Europe by Henry B. Nason of the Rensselaer Polytechnic Institute and Dr. J. Francis Williams during the summer of 1887 at the request of Charles Pratt. Williams, a graduate of Rensselaer and the University of Göttingen, served as curator of the museum until

his departure in 1889. Pratt modeled the museum on those of industrial design schools in Europe. Its aim was "to show the gradual development from a raw or crude material to an artistic and finished product."[68] By 1889 the collection consisted of 6,840 specimens purchased throughout this country and abroad. The museum received frequent usage; records for 1890 indicate a total of 8,289 visitors during the year. Objects in the museum included examples of glass, porcelain, iron work, enamels, bronzes, textiles, minerals, rocks, crystals, chemicals, gunpowder, and steel. Many of the works were of considerable historic and artistic value, with porcelain from Meissen, Sèvres, Limoges, Dresden, and Copenhagen. The museum also featured 18th century Delft ware, Wedgwood, a 13th century German vase, and Chinese and Japanese porcelain.

In 1890 the museum began to expand its holdings of art with acquisitions of wood carvings, marbles, antique vases and several bronze animal sculptures by Antoine-Louis Barye.[69] This direction was encouraged by Hopkins, who supervised the museum unofficially until his 1893 appointment as director. In 1892 the faculty passed a resolution to establish one location for the museum's "historic art, artistic productions, reproductive art...casts, drawings, photographs, etc." and to disperse the "technical collections" to their respective departments.[70] Hopkins devoted much of his administrative time to buying and cataloguing the photographs which eventually totalled over 15,000.[71] These documentary images of paintings, sculptures, graphics and architecture were intended to illustrate the complete history of art through the nineteenth century. They were purchased from museums, galleries, salon exhibitions, and dealers on several trips abroad by Perry, Hopkins, and Herbert Adams, Pratt's professor of sculpture. While the majority of the photos were acquired from Braun, Clément & Co., others were supplied by Giraudon (Paris), Alinari and Cook (Florence), and Hanfstaengle (Munich). The success of the photographs can be measured by their impact on students like

Gertrude Käsebier, one of Pratt's most renowned female alumni, whose early works reflect their influence in composition and lighting.[72]

Hopkins conceived of the museum, together with the library and school, as an educational triumvirate. Its primary purpose was not to exhibit collections, but to supply teaching material. He wrote that "the school museum must be considered as a laboratory," providing contact with objects (or their images) which complements information acquired through reading.[73] For Hopkins, "one cannot grow to its fullest development without the other; for what are all the illustrations of the Venus of Melos…without the knowledge of contemporary men and events, which only the books of a library can supply."[74] Context and display were essential to pedagogical success. Following the lead of German museums, Hopkins believed that historical knowledge was imparted through a systematic chronological arrangement. He praised the Albertinum in Dresden and the Boston Museum of Fine Arts, where "even a child…must carry away some idea of periods and schools."[75]

Lacking a separate building for his exhibits, Hopkins, together with Perry, transformed Main Building into a museum where students could absorb principles of beauty. Photographs were hung sequentially along hallways from the basement to the fifth floor, in classrooms, and even in the campus restaurant, opened in 1894. Guests at Pratt were quick to notice this feature. Isaac Clarke reported admiringly that "the visitor to the Pratt Institute finds himself at once as he enters the hall and makes his way up the stairs, in an atmosphere of art; for, everywhere, his eye rests on well-framed photographs of examples of the best work of the world's architects and artists."[76] Images not on view were housed in the Photograph Reference Room, furnished with tables and chairs, to be consulted by students. Each week new photos were hung on the walls to illustrate material discussed in Perry's art and design history lectures.[77] These talks, begun in 1890, were soon a regular part of the curriculum and, by 1894, were required not only for art majors,

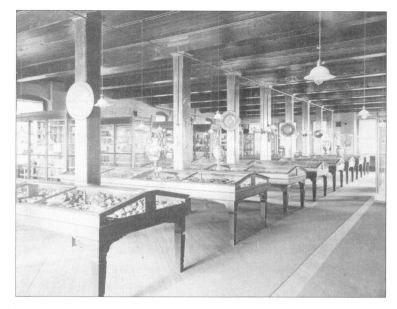

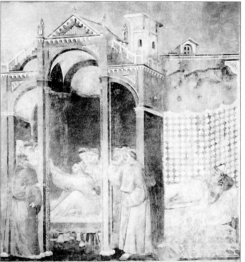

Above: The Technical Museum at Pratt.

Below: *Dying Friar Sees St. Francis Carried into Heaven* by Giotto. Reproduction photograph by Braun, Clément & Co., c. 1890.

who had to submit notes and take tests, but also for students in the High School, Normal School, and Domestic Arts. The titles of all the lectures for the year were published in the school catalogue. Perry's talks presented historical periods in chronological order and were accompanied by lantern slides. They were a unique addition to the program at a time when art history was generally taught only in colleges and universities.

Sake bottle and cup, Japanese, 18th century, lacquer, 8 3/4 x 4" diameter (bottle); 2 1/4 x 3 1/2" diameter (cup). Collection of the Brooklyn Museum of Art, Gift of Mrs. Frederic B. Pratt, #30.1463-64. Photo: Brooklyn Museum of Art

John LaFarge, *The Ascension*, 1885-86, sepia on paper, 20 3/4 x 11 3/4". Collection of Mount St. Mary's College Library, Special Collections, Emmitsburg, Maryland

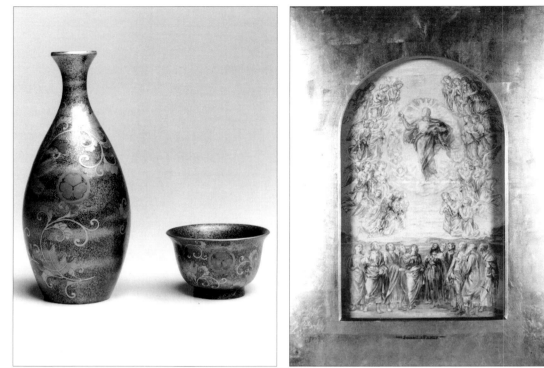

Edwin H. Blashfield, *Study for Mural in the Library of George Drexel*, 1895-96, photograph, collage and paint on wood, 18 7/8" diameter. Collection of Bayly Art Museum of the University of Virginia, Gift of Mrs. Florence K. Sloane

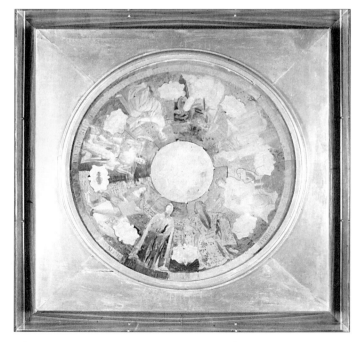

Vase, c. 1899-1905,
Grueby Faience
Company, glazed earth-
enware, 9 x 2 3/8" diam-
eter (base). Collection of
the Brooklyn Museum of
Art, Gift from the
Collection of Edward A.
Behr #61.113. Photo:
Brooklyn Museum of Art

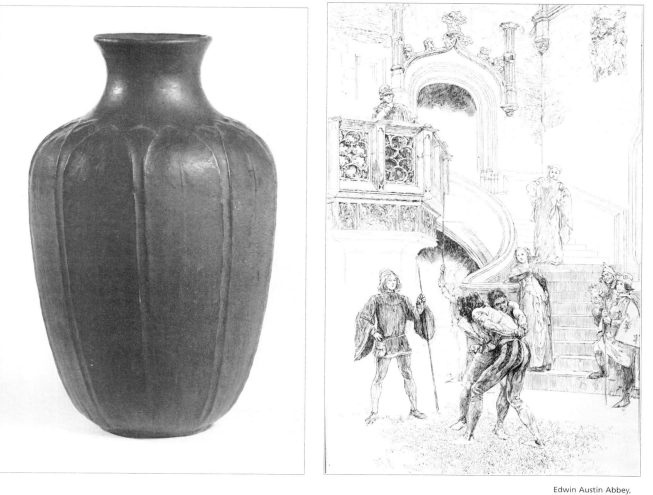

Edwin Austin Abbey,
*Study for Wrestling
Scene from "As You
Like It,"* n. d., pen and
ink on paper, 21 x 13
1/2". Collection of Yale
University Art Gallery,
The Edwin Austin
Abbey Memorial
Collection. Photo: Yale
University Art Gallery

Frank Vincent DuMond, *Woman at Window*, 1901, illustration for *Harper's*, 26 x 18 1/2". Collection of N. Robert Cestone

Robert Blum, *Little Japanese Girl*, n. d., watercolor on paper, 13 x 8". Collection of Berea College, Berea, Kentucky, #140.W.6

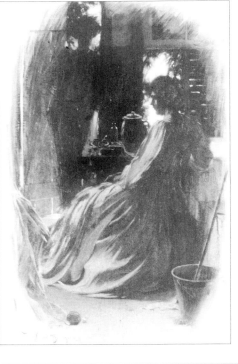

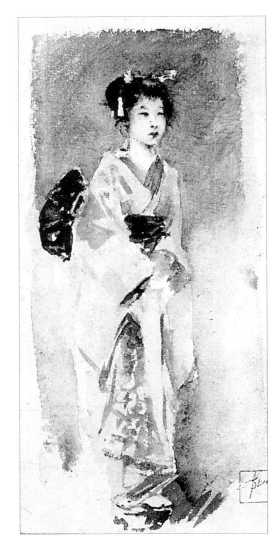

Will Bradley, *When Hearts are Trump by Tom Hall* (plate #52 from the Maitres de l'Affiche series), 1894, lithograph, 9 3/4 x 7 7/8". Courtesy of Park South Gallery, New York

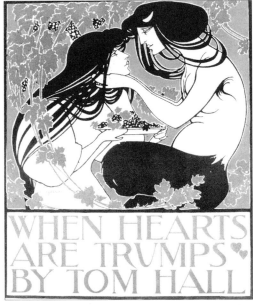

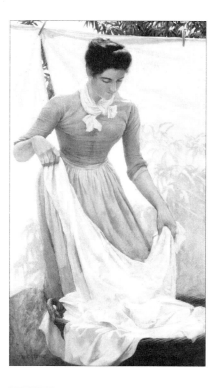

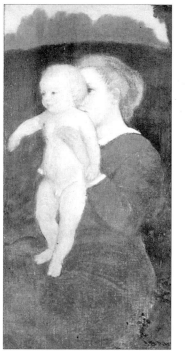

Charles C. Curran, *Wash Day,* 1887-88, oil on canvas, 54 x 30". Courtesy Adelson Galleries

Arthur B. Davies, *Mother and Child,* 1896, oil on canvas, 11 1/2 x 5 5/8". Collection of the Utica Public Library, Utica, New York

Frank Vincent DuMond, *Christ and the Fishermen,* 1891, oil on canvas, 52 x 60". Collection of N. Robert Cestone and Steven V. DeLange

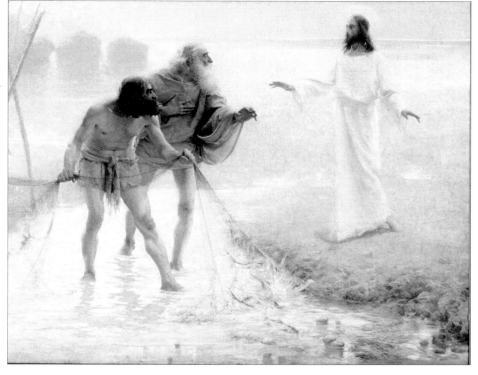

Arthur Wesley Dow, *Ipswich Bridge*, c. 1895, colored woodcut, 5 x 2 1/4". Private collection

Alvin Langdon Coburn, *The Bridge, Ipswich*, 1903, photogravure, 7 9/16 x 5 7/8". Courtesy of Gallery 292, New York

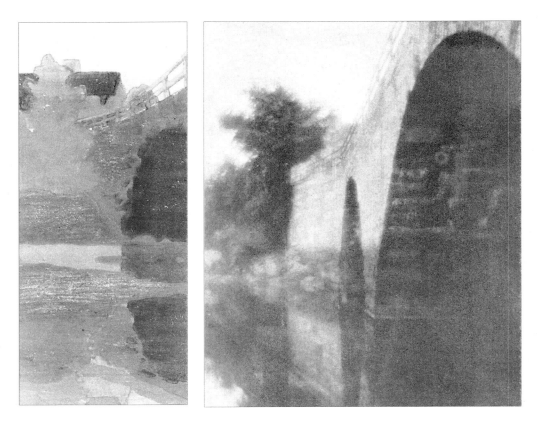

Arthur Wesley Dow, *Au Soir*, 1888, ink on paper, 5 1/4 x 8 7/8". Collection of Barbara Wright

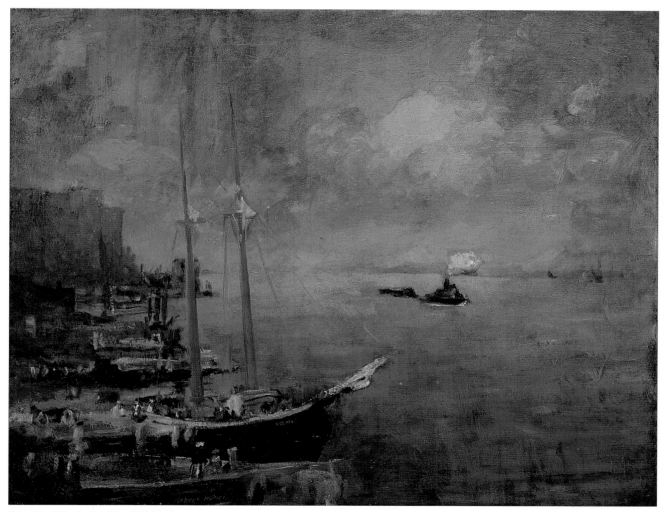

Robert Henri, *On the East River,* 1900-02, oil on
canvas, 28 x 32". Collection of the Mead Art
Museum, Amherst College, Gift of Mr. and Mrs.
Richard Rogin. Photo: Mead Art Museum

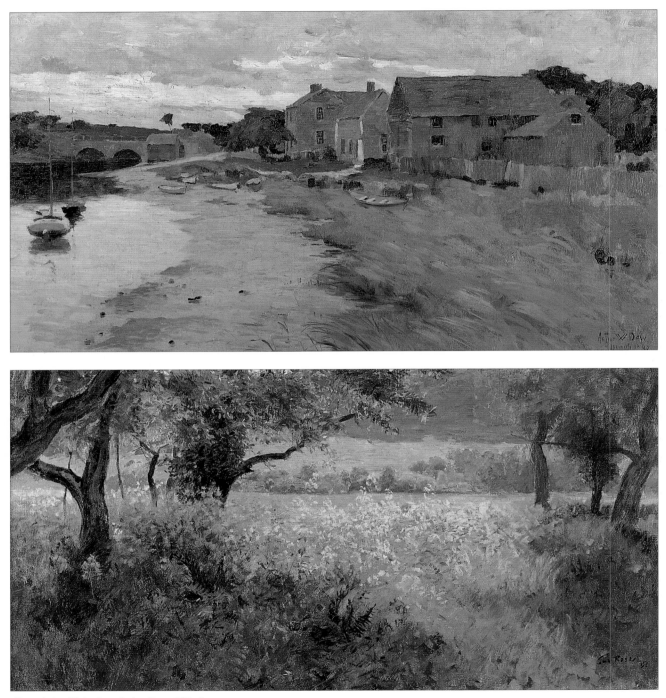

Above: Arthur Wesley Dow, *Turkey Shore,* 1890, oil
on canvas, 17 3/4 x 31 5/8". Collection of the First
National Bank of Ipswich

Below: Guy Orlando Rose, *July Afternoon,* 1897, oil
on canvas, 14 3/4 x 29 3/4". Collection of Roy C. Rose

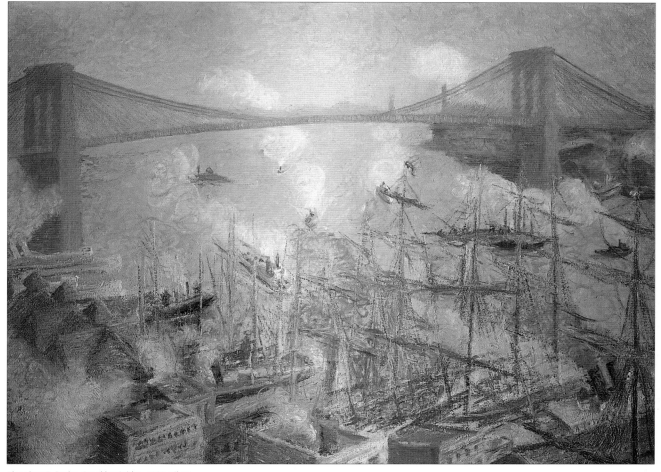

Theodore E. Butler, *Brooklyn Bridge*, 1900, oil on
canvas, 30 x 40". Private collection. Photo: R.H. Love
Galleries, Chicago

Arthur Wesley Dow,
Little Venice,
1893-95, three color
woodcuts, each 4 7/8
x 2 1/8". Collection
of Barbara Wright

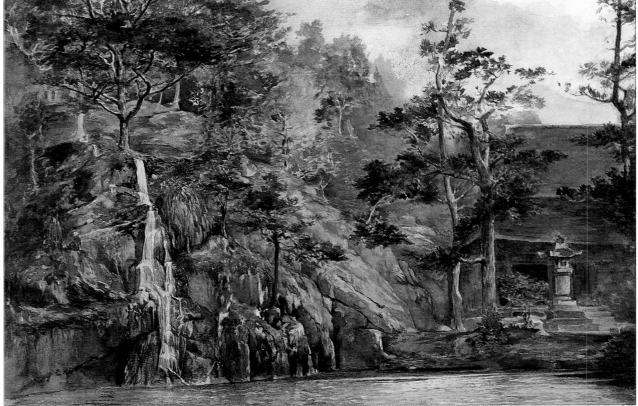

John LaFarge, *Waterfall of Urami-No-Taki,* c. 1886,
watercolor on paper, 10 1/2 x 15 1/2". Collection of
the Addison Gallery of American Art, Phillips
Academy, Andover, Massachusetts #1984.21. Gift of
Mr. & Mrs. Stuart P. Feld. Photo: Addison Gallery

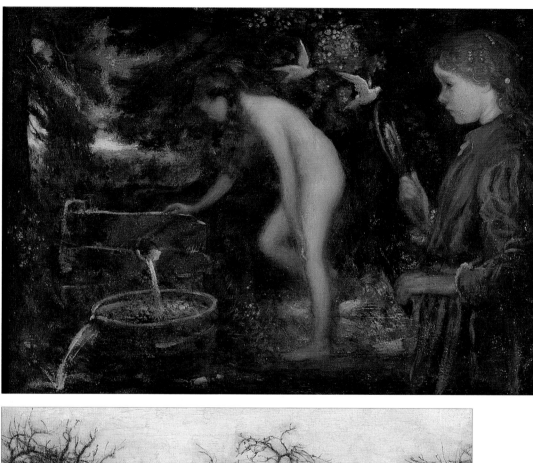

Arthur B. Davies,
The Source, 1896, oil
on canvas, 12x15".
Collection of the Frances
Lehman Loeb Art Center,
Vassar College,
Poughkeepsie, NY

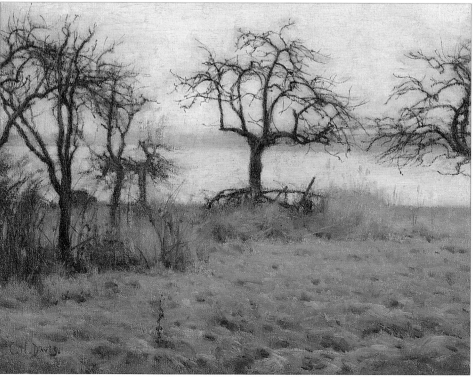

Charles H. Davis, *Grey
Day Early Winter,* 1892,
oil on canvas, 15 x 18".
Private collection

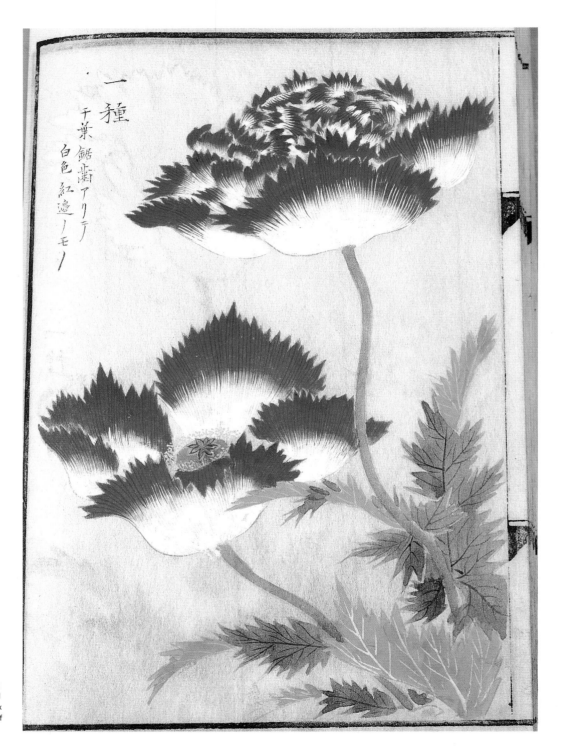

Anonymous, Album of botanical studies, Japanese, Edo Period 1800–1850, color and ink on paper, 10 1/2 x 7 x 1/2". Collection of Julia Meech

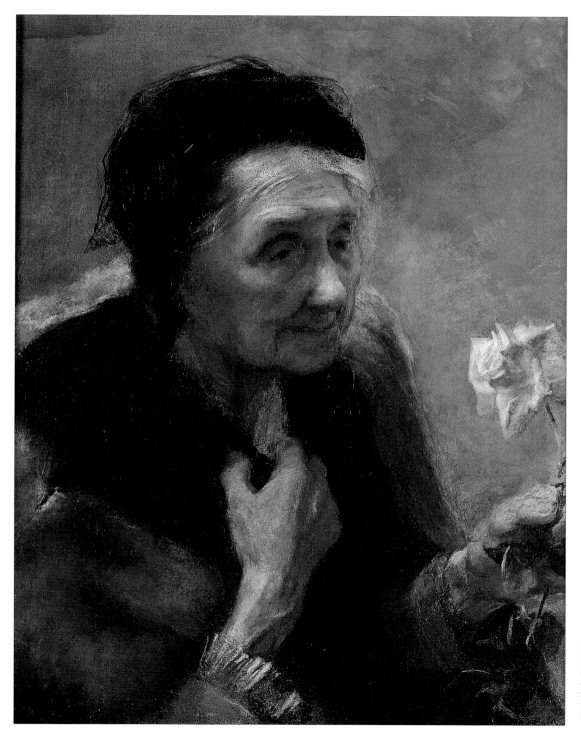

Edith Prellwitz,
The Rose, c. 1896–99,
oil on canvas, 25 x 18".
Collection of
Sam Prellwitz,
Pittsburgh,
Pennsylvania.

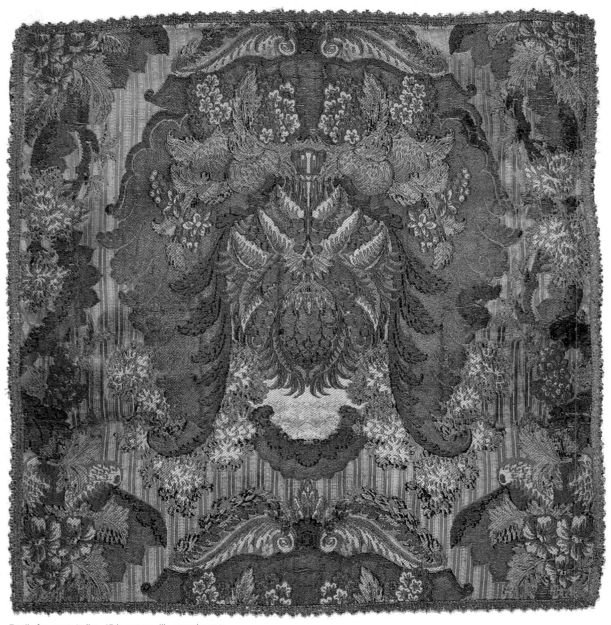

Textile fragment, Italian, 17th century, silk cut and uncut
velvet, 8 1/4 x 10". Collection of the Brooklyn Museum of Art,
Gift of Pratt Institute, #34.168. Photo: Brooklyn Museum of Art

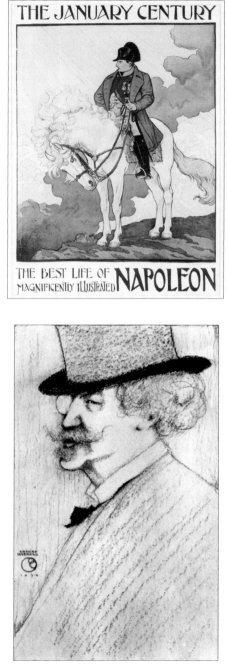

Eugène Grasset, *Napoleon*, 1894, color lithograph poster, 27 1/4 x 19". Collection of Mark J. Weinbaum

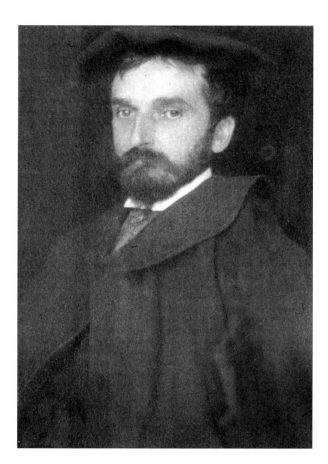

Gertrude Käsebier, *Arthur Wesley Dow*, 1896-98, platinum print, 6 3/4 x 4 3/4". Collection of Barbara Wright

Ernest Haskell, *Portrait of Whistler*, 1898, platinotype reproduction of charcoal drawing, 14 x 20". A. E. Gallatin Collection, Print Collection, The Miriam and Ira D. Wallach Division of Art, Prints and Photographs, The New York Public Library, Astor, Lenox and Tilden Foundations. Photo: The New York Public Library

Edward Penfield, cover
of *Harper's,* February
1894, lithograph, 15
13/16 x 11 7/8".
Collection of Mark J.
Weinbaum

Max Weber, *Abstract
Tassels,* 1914, gouache
on paper, 23 3/8 x 11
1/2". Courtesy of Forum
Gallery, New York

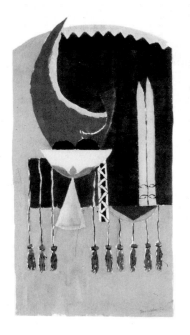

Henry Prellwitz, *Dante
and Virgil,* c. 1897, oil
on canvas, 30 1/2 x 48".
Collection of Ronald G.
Pisano, Inc.

Robert Reid, *Summer Breezes,* c.
1896, oil on canvas, 25 x 30".
Courtesy of the Reading Public
Museum, Reading, Pennsylvania

Pamela Colman Smith, *The Land
of Heart's Desire,* triptych illustrat-
ing a play of the same name by
William Butler Yeats, c. 1898,
hand-colored process print, 11 3/4
x 20 1/8". Collection of Melinda
Boyd Parsons

Clarence White,
The Readers, 1897,
photograph, 7 7/16 x 4
1/8". Collection of The
Licking County
Historical Society,
Newark, Ohio

Hopkins' concern with the educational mission of museums also found an outlet through his participation in the School Room Decoration movement. In both cases, art was "democratized" through reproductions in an age when travel abroad was inaccessible to most, and even good photographic reproductions were rare. Throughout this era, museums were customarily regarded as agents of social reform through the civilizing effects of beauty. Ernest Fenollosa, the curator of Japanese Art at the Boston Museum of Fine Arts who was later hired at Pratt, articulated the beliefs of liberal educators in his article, "Art Museums and their Relation to the People." Basing his arguments on the premise that beauty "is the inspirer of the noblest, of the most unselfish…of human moods," and that art education "is a duty we owe especially to the poor, the children of the laboring classes," he concluded that "it is for them that we endow our public libraries, for them that we found our art museums." Fenollosa endorsed the use of reproductions:

> [They] render effective art museums more possible, universal, and valuable. Both the great and little museums must supplement their stock with fine casts and photographs, now both accessible and cheap. In this way each museum may possess the best in history for full comparison and study. It is this new fact which renders our day, in a special sense, the era of museums; that which makes the museum analogous to the nature of a library.[78]

Hopkins also saw the school museum as philanthropic, shedding "its light into the darker portions of the city, illuminating and making bright, as only art influence can, the pathway of its students who turn aside to do mission work therein."[79]

At Pratt, however, students did not have to rely only on reproductions. These were augmented with original examples of applied art from the museum and, after the mid–1890s, with work by leading contemporary artists. The new gallery began inauspiciously in April 1894 when Hopkins organized a loan exhibit of Greek glass in a fifth floor room of Main Building. This show, presenting the collec-tion of Dr. Shepard, a missionary in Turkey who acquired the pieces from ancient tombs near Palmyra, was little different from the permanent displays in the museum.[80] During the next two years it was followed by increasingly ambitious exhibitions around which Hopkins launched a vigorous campaign to lobby Frederic Pratt for increased funds and a well-equipped space. In his report to Pratt on the first show, Hopkins introduced his two most persuasive arguments, frequently repeated: publicity and educational value. He wrote, "This case of glass has attracted many visitors. Several students have made extensive sketches, and I understand color studies as well."[81]

The Shepard Collection was followed that spring with a display of drawings for illustrations loaned by Charles Scribner's, a young company founded the same year as Pratt. Much of the material had previously been seen at the World's Fair and was, according to Hopkins, "of great value" to the students. A year later (May 1895) he repeated the exhibition in expanded form with works loaned by several publishers and magazines including *Century, Harper's,* and *Life.* This show, reviewed in the *New York Tribune,* contained drawings by leading artists Edwin Austin Abbey, Charles Dana Gibson, Kenyon Cox, and Howard Pyle.[82] In October 1894 Hopkins organized an exhibit of objects (textiles, ceramics, wood-carvings and bronzes) collected by Frederic Pratt on his trip to Japan earlier that spring. He reported enthusiastic public response, adding "from day to day come the suggestions of how valuable a series of such rooms would become could they be provided and properly filled."[83]

By far the most successful of the early shows was the poster exhibition in March 1895 which attracted over twelve hundred visitors and received extensive press coverage. The posters by American, French and British artists were borrowed from thirteen different collectors, including Louis Evan Shipman and Louis Read who also provided assistance with organization.[84] Illustrated reviews were published in the *New York Tribune* (March 17, 1895) and elsewhere. This exhibition, together with the previous one of Japanese art, established Pratt's

vanguard credentials; the first New York shows of posters and Japanese prints had only recently taken place at the Grolier Club in 1889.

Bolstered by these triumphs, Hopkins made a persuasive case for permanent gallery space in the new library building soon to be under construction:

> After one year's experiment, we are thoroughly convinced that artists and collectors would be only too glad to send their work to us. We cannot continue this most valuable feature unless some satisfactorily lighted, permanent home is granted us. Such a room could be filled from October to June, with never a break, and could do for the school and its students that which can never be accomplished in any way. The Museum and its exhibitions have done something to attract visitors to the school; it is hoped they may do more in this direction. May it not be wise in the near future to consider this matter, looking toward the granting of more suitable, permanent quarters.[85]

Hopkins' predictions would be fulfilled far beyond his expectations, with more than fifty shows—many of prominent artists—held during the next decade. By 1898 a reporter for the *New York Post* noted that "the frequent exhibitions held at the Pratt Institute invite attention to the work which is being accomplished in that nucleus of activities."[86]

Hopkins was granted his wish and a gallery with "top lighting" and "special electrical arrangements" opened on the third floor of the Library in May 1896.[87] Appropriately, the room was adjacent to the new Art Reference Room for photographs, thereby uniting images and texts under one roof in accordance with his original vision. These features were singled out for praise in *Art Notes* (1896), the publication of the Macbeth Gallery. The author proclaimed himself "amazed" at the "scope and completeness" of the "art reference rooms and lecture halls," and described the "frequent special exhibitions" as "quite unique in character."[88]

The inaugural show was a traveling exhibition of Swedish paintings organized by Anders Zorn and secured by Frederic Pratt from the Art Institute of Chicago. Reviews appeared in *The New York Times* (May 27, 1896) and *Modern Art,* indicating the considerable interest by Americans in Swedish art following the display at the Columbian Exposition.[89] Attendance at Pratt topped three

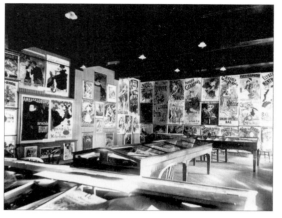

Poster exhibition in the Main Building, March 1895.

thousand with 483 catalogues sold. Participating artists included Zorn, Karl Nordström, Nils Kreuger, Per Ekström, and Carl Larsson. For Hopkins the exhibition was a vindication of his ambitions. In anticipation of the opening, he observed with considerable satisfaction:

> To see our name on the catalogue in connection with the Pennsylvania Academy of Fine Arts, the Cincinnati Museum Association, the St. Louis School and Museum of Fine Arts, the Art Institute of Chicago and the Boston Art Club [other venues] is, at least, a great pleasure and will do much to eradicate the impression still abroad in this country that Pratt Institute is a trade school. This is the first experiment along these lines and we shall watch its outcome with a great deal of interest.[90]

Hopkins, however, did not remain to watch. He left Pratt before the show opened to begin his new position as Director of Drawing Education in the Boston Public Schools. His duties were transferred to Walter Perry, who organized future exhibitions and managed the photography and cast collection.[91]

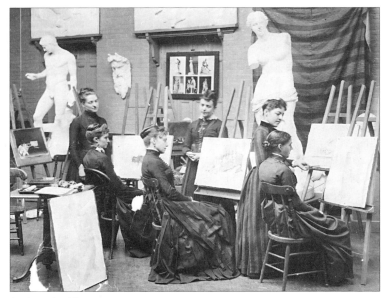

Students sketching
from plaster casts.

Academic Training in the Department of Art

THE "IMPRESSION" that Pratt was still a trade school would also have been quickly dispelled by a glance at the Department of Art curriculum. Perry took the challenge to train designers as artists literally, adding courses that would make the school competitive with art academies. His department comprised three main divisions: Regular (fine arts), Design, and Normal (teaching training) with optional specializations.[92] The Regular degree was expanded in the fall of 1891 to become a four-year program. A year later it resembled the training provided by an academy, beginning with antique cast drawing and continuing in the second year through life drawing and anatomy to painting from life during the final two years. Instruction in composition was introduced only in advanced courses.[93] A description of the program in the catalogue underscored this new orientation, stating that "Much emphasis is placed upon work from life, and unlimited opportunity for study is given in this direction. This substitution of life drawing

for continued work from the antique accords with the theory and practice of the best European schools, and students are encouraged to enter life classes as early as possible."[94] Perry reiterated this feature in his report at the end of the year, noting that "the fine arts division is a school quite distinct in itself, carrying drawing from the antique, and drawing and painting from life, as far as any art school."[95] Between 1893 and 1896 Pratt hired established figural painters Frank Vincent DuMond (who also worked at the Art Students League), Henry Prellwitz, Charles Curran, and Guy Rose to teach at the school.[96]

While the fine arts division may have been "distinct" in advanced work, all first-year students in the department attended courses together in cast drawing, still life drawing, perspective, color, sketching, and art history. (Copying from engravings, a common practice in both academies and South Kensington-style design schools, was banished). In subsequent years pupils diversified into specialized programs, but designers were encouraged to take classes in anatomy and life drawing. This arrangement was unique among art schools, fostering an integral education for fine and applied artists based on academic training and exposure to historical examples of art. It more closely resembled systems in France, where designers studied life drawing with *beaux-arts* students. Many attributed France's superiority in the decorative arts to this method. Clarke summarized this view in his study of Pratt, with advice that appears to have been heeded:

> The experience of the French seems to demonstrate that the surest way to develop a race of successful designers for artistic industries is to train large numbers of pupils in the Schools of High Art. To give the art instruction first, and wholly without reference to its application to the industries; letting the artists direct this art knowledge to whatever end may subsequently seem desirable.
>
> This is so contrary to the idea which seems to prevail in this country and, moreover, the present educational impetus towards a more

industrial 'practical' training is so well nigh irresistible, that I may, perhaps, be pardoned for expressing, in this connection, the hope that in this grand modern institution so lavishly endowed by Mr. Pratt, there may be found room…for this general training in High Art, without which artistic industries starve.[97]

Pratt was an unusual hybrid, comprising an unprecedented merger of British Arts and Crafts ideology wedded to French pedagogical practice. As noted in an 1894 article in *The Century Magazine,* "the principle kept constantly in view is that efficient special training must rest upon sufficient general training in art."[98] For Perry, this was possible because of the school's diversity and scope, allowing students to change majors easily and to have their creativity stimulated by a variety of different course offerings. He reported to Frederic Pratt in 1893:

> The Art Department of Pratt Institute embodies all these [types of fine and applied art education] in one. This peculiar union very much strengthens the various lines of work carried on in the department…and thus strong, broad work is done in every subject. Because of this you can decide later to specialize after a solid general training…. As the school of design is so directly connected with the school of fine arts, students have unusual opportunities for drawing from the antique or from life, and are thus enabled to gain much valuable practice in this direction.[99]

Fenollosa, Dow and *Japonisme*

PERRY'S SMOOTHLY RUNNING academic curriculum was soon to be disrupted, however, by the arrival in September 1895 of Arthur Wesley Dow with his radical new methods for integrating art and design training through shared principles of composition. These innovations would soon change art pedagogy throughout the country and

contribute to the beginnings of modernism and the decline of academic training. Through Dow, Pratt moved resolutely into the forefront of art education reform. It was Frederic Pratt who, somewhat unwittingly, initiated this direction in the fall of 1894 when he invited Dow's friend Ernest Fenollosa to speak at Pratt. His interest in Fenollosa, about whom he had heard favorable comments from John Clark and Perry, stemmed from his love of Japan. Frederic and his wife had travelled there for three months (March through June) during the spring, using a letter of introduction from the painter John LaFarge.[100] Pratt was one of a growing number of collectors and artists journeying to the East in the final two decades of the century. Prominent among them were LaFarge and Robert Blum, Bostonians Edward Sylvester Morse and William Sturgis Bigelow, New Yorkers Howard Mansfield and Charles Stewart Smith (both Trustees of the Metropolitan Museum of Art), and Detroit industrialist Charles Lang Freer.[101] Pratt's collection, mentioned earlier, was purchased in Japan, although he continued to buy books and prints after his return.[102]

Fenollosa was unique among Western Japanophiles because he had lived there for more than ten years, working at the Imperial University in Tokyo first as a professor of philosophy and political economics in 1878, and then, from 1886, as an Imperial Commissioner in the Department of Education charged with establishing the first Fine Arts Academy in Japan. He returned to Massachusetts in 1891 as curator of Japanese Art at the Boston Museum of Fine Arts.[103] Frederic Pratt's invitation to Fenollosa was motivated by a desire to further encourage the school's interest in Japanese culture already apparent in *Monthly* articles and the iron dragon bell suspended over the entrance to the museum. A report on the Japanese exhibit in Jackson Park at the Columbian Exposition praised their superior craftsmanship, educational system, and character which contrasted with American "impertinence" and "condescension."[104] Frederic Pratt delivered a lecture, "A Visit to Japan," in

February 1895 at a meeting of the Neighborship Association Chapters in the Institute gymnasium which was filled with displays of Japanese crafts. The evening concluded with a demonstration of

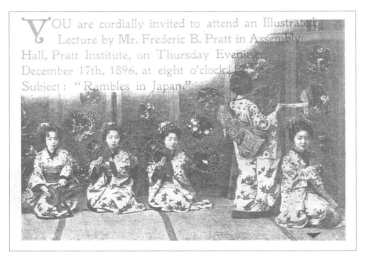

YOU are cordially invited to attend an Illustrated Lecture by Mr. Frederic B. Pratt in Assembly Hall, Pratt Institute, on Thursday Evening, December 17th, 1896, at eight o'clock. Subject: "Rambles in Japan."

Announcement of Frederic Pratt's Japanese lecture, 1896

the tea ceremony.[105] He followed this with another talk on Japan at Pratt in December 1896. Frederic wrote to Perry on September 4, 1894:

I have not met Prof. Fenollosa, but from what I hear of him, I judge he is a remarkably intelligent man. It is the spirit that he stands for that I wish to see placed in all the art work of the Institute. I know of no people who seem to possess it in a greater degree than the Japanese. We surely must have a talk from him at some time.

In October he communicated with Fenollosa for the first time, inviting him to visit during his upcoming trip to New York to speak at the Brooklyn Institute of Arts and Science on the 19th.[106] Fenollosa accepted and a discussion about "work at the Institute" took place.[107] The lecture, "The Influence of Art Education on the Social and Material Prosperity of a People," summarized in the *Monthly*, would have reinforced Pratt's interest in Fenollosa. He presented an egalitarian (albeit patronizing) definition of art whose moral function was aimed, via the public schools, at social reform

benefitting not only individuals, but the nation. Most of the issues discussed echoed opinions by Pratt faculty and other liberal educators.[108] Fenollosa stated:

Art education is for the people, not for a select few. While the rich man can buy art, the poor can get it only in a general universal way…. The subject is introduced in the public schools, not to make artists of the students, but to cultivate their appreciation for the good in art, to make their lives purer, more refined; to lead them to see the beautiful in all things, and to make them better citizens.[109]

For Fenollosa, art was not "mere technical skill" or a "mere subject of pleasure," but extended to "harmony in things about us" and "the right adjustment of all the relationships of life." The *Monthly* reporter concluded, "Those who are training to become teachers of art education went away with the feeling that they have a mission in life that includes something more than the performance of technical work."[110] Privately, in a memorandum written to himself in 1891 after his return from Japan, Fenollosa revealed the full extent of his proselytizing zeal: "I must here become a preacher and prophet appealing to all that is noble and inspiring in man's experience…. the art function must be duly subordinated to, or rather synthesized with, all efforts toward moral and political construction…. By giving them [the poor] more highly skilled manual and artistic education, we shall also give these very laborers the power to assist in the beautifying of our cities and homes."[111]

Given these agendas, Fenollosa must have viewed Pratt Institute as the perfect platform from which to launch his program. Indeed, it was Fenollosa who proposed the idea of a more long-term relationship between himself, Dow, and Pratt in the form of additional talks and some teaching. This suggestion, made while Frederic was in Boston in April, initiated a lengthy period of negotiations and investigation. Frederic wrote to John Clark on April 12, asking him to gather some

"confidential opinions as to his ability, ideas and practical work" (and salary) from the trustees of the museum and men "like Denman Ross," a collector, writer, and teacher whom Pratt admired.[112]

Clark responded with two letters. Surprisingly, considering his initial recommendation of Fenollosa to Pratt, Clark had serious misgivings about him and Dow. He reported that Denman Ross "of course very strongly favors him [Fenollosa]" because of their close friendship, but that the directors of the museum's art school were less enthusiastic."[113] Clark praised Fenollosa as a brilliant thinker: "one of our ablest men on the idealistic side of art...whose influence is very much needed in these prosaic days."[114] Nonetheless, Clark doubted whether he would be right for Pratt because of his lack of experience in public education and "the practical industrial side of the question." These criticisms about Fenollosa—and Dow—would be repeated during the coming months while Frederic Pratt deliberated. Clark's hesitations may have been partly motivated by professional jealousy. He concluded that while they might exert a good influence at Pratt—especially Dow as a practicing artist— nonetheless they would not introduce "any essentially new principles in their teaching other than what we who are working under the Prang banner have for some time been endeavoring to put into our work in the schools."[115]

Most of Frederic's sleuthing concerned Dow, who was at that time relatively unknown. Dow, a native of Ipswich, Massachusetts, had studied art in France from 1884–89 at the Parisian Académie Julian with Gustav Boulanger, and in Pont-Aven, Brittany while Gauguin worked there. By 1891, when he met Fenollosa in Boston, he had already fallen under the spell of Japanese prints, whose techniques he would adopt in his own colored woodcuts of Ipswich landscapes. He became the assistant curator of Japanese Art at the Boston Museum of Fine Arts in 1893 and began teaching classes in Boston and, during the summer, in Ipswich. Ideas contained in his first article on Japanese art (1893) and in lectures he gave to the Boston Art Students' Association indicate that by 1895 his theories, heavily influenced by Fenollosa, were fully formed.[116] According to the assessments presented to Pratt, however, his teaching methods and art were still works in progress. Clark, while noting praise from "Mr. Tarbell and Mr. Benson of the Museum Art School," concluded that his art "does not fire any one with enthusiasm" and that "he yet seems to be striving after something he has not yet fully realized, as though he were working for an ideal which somehow just eludes him."[117]

Perry was also busy soliciting opinions from students who had attended Dow's classes; during the summer a Pratt faculty member was dispatched to Ipswich to evaluate his performance. The first report was received by Perry on April 16th from Kate Foster, an assistant to Mary Dana Hicks at the Prang Company. Foster had met earlier with Frederic Pratt while he was in Boston. She criticized Dow's approach to art through "principles of structure" as too abstract, observing that "it could only be fully comprehended by those who had already given a good deal of thought and study to the subject." Voicing several objections repeated in other evaluations that summer, she noted that his work needed to be more systematized and accompanied by technical instruction, and that he provided insufficient training in representational drawing. She also observed that he possessed inadequate knowledge of children and public school conditions. Additionally, she was not impressed with his teaching abilities: "he is not particularly strong as a teacher...he says very little and calls upon us to do a great deal." These viewpoints typified the conservative reaction to Dow's innovations and, given his future success, seem shortsightedly imperceptive.

Frederic Pratt remained skeptical, writing frequently to Dow and Fenollosa that spring regarding arrangements for them to visit the school. Dow would eventually make the trip in June in order to attend the annual student exhibition. A letter from Frederic to Dow in April also indicates that he had read the catalogue for Dow's exhibit of color woodblock prints at the Boston Museum of Fine Arts.

This show would be repeated at Pratt during the fall. Frederic praised Fenollosa's essay, but questioned his claims about Dow's originality, suggesting that a French artist, seen at a recent American Art Association exhibit, was already appropriating Japanese techniques. The man to whom Frederic referred was undoubtedly Henri Rivière. The AAA catalogue emphasized his affiliations with Japan, stating, "No painter in Paris has come closer...to the spirit of Japanese art than Henri Rivière."[118]

In late April Perry wrote two letters to Frederic expressing intense opposition to the proposed appointments. They were inspired apparently by private negotiations between Pratt and Fenollosa in which Fenollosa demanded extensive curricular changes, with authority over several classes and a guaranteed number of students. Perry clearly felt himself and his program threatened and responded in panic. He based his objections on the unproven "experimental nature" of Dow's method and his lack of training in the technical component of design. Perry feared that Pratt's design work would no longer be "recognized by the trade" and he argued, "we must continue to incorporate a certain amount of the technical or trade element in it. In doing this, we can still make our work artistic and progressive."[119] This was a reversal of Perry's previous position, arguing on behalf of aesthetic content in manual training.

Perry's real concern, however, was revealed at the end of the letter. He demanded, "Is he [Dow] to become, out and out, one of my teachers? Will not the Trustees eventually hold *me* responsible for the general condition of the work, the attendance of students, our standing with other schools, etc.?" Nonetheless, he concluded more cautiously, praising Dow's "most excellent ideas," with a statement reiterated frequently over the next few months: "I am not opposed to Mr. Dow; I have recommended Mr. Fenollosa...but their methods must be *engrafted* onto the current curriculum." It is not altogether unexpected that Perry praised Dow's ideas, since the theoretical beliefs of both were more similar than is customarily acknowledged. It is probable

that Perry would not have raised objections unless provoked by Fenollosa's attitude. His next letter, written after having read Fenollosa's, reached a more hysterical pitch. He found the proposed changes "sweeping" and "dogmatic" and predicted that they would destroy "the unification of our work" at Pratt.[120] He reiterated the need for the gradual incorporation of new untested methods and threatened Frederic with a vision of Pratt's future deserted by its students.

Despite such dire warnings, Frederic proceeded with his plans, initiating negotiations over salaries and teaching schedules by July. In early August he and Perry travelled to Ipswich to observe Dow's work firsthand. Surprisingly, Perry had experienced a change of heart, apparently satisfied with reassurances that Dow's courses would be integrated with other classes and under his supervision. Perry expressed his support in a letter of August 16th, in which he also recorded a meeting with Denman Ross and attached statements by three of Dow's students.[121] Two of these, Miss Nourse and Miss Stocking, the latter a Pratt faculty member in the Department of Domestic Art, were unsympathetic with his approach. Nourse faulted him for an inability to give direct, helpful criticisms in a systematic way, and Stocking considered him a "weakling" who had not advanced her knowledge of design. Perry dismissed these complaints, observing that Miss Stocking "has her limitations just as soon as she gets away from her needlework." By contrast, Miss Palmer's evaluation soundly endorsed Dow, noting that "his ideas are right," and regretting that "my early training was not one that cultivated imagination."[122] Perry praised Palmer, describing her as a "level-headed" woman with broad ideas and a "thoughtful way of looking at things."[123] He included a drafted teaching schedule for Dow, but warned that a cooperative spirit must be maintained with the other faculty: "their ideas cannot be kept private...there should be the most cordial union of effort."[124]

At this juncture, with the beginning of the fall semester only a month away, Frederic wrote to

Fenollosa and abruptly cancelled the whole arrangement, explaining that he was "deeply disappointed" in the design work of the Ipswich class. Perhaps more to the point, he added that "it would be unwise for us to assume such a large added financial obligation to the Art Department" until Dow proves his methods successful.[125] To Perry he confided that, after a discussion with his brother Charles, he had decided that the risk was too great given the financial investment, and that Dow was insufficiently equipped to teach industrial design. Perry replied on August 24th, expressing his extreme surprise over the decision at such a late date and arguing on behalf of Dow. While admitting that Dow was inexperienced, he maintained, "I have no doubt but what much good might come from Mr. Dow's connection with the department." He concluded by praising a Dow landscape he had just seen and quoting a statement by Miss Palmer: "Dow seems to me a rare man in his quiet earnestness and great love for the best in art."[126]

Fenollosa responded immediately with a lengthy letter, appealing to Frederic's vanity as a visionary patron of art education, and bluntly stating that it was unfair to judge Dow on the basis of a few designs completed in a summer landscape class. His other comments were addressed to the recurrent issue of balancing creativity with the technical proficiency required by manufacturers. Fenollosa harshly criticized the quality of industrial design at Pratt "ground out like machinery productions, cold, metallic, and lifeless," and faulted the domineering "political" influence of commercialism. He wrote:

> If it seems to you that the demand of the manufacturers is still for design of the mathematical, cast-iron type, I think you with your intelligence, and the responsibility it entails, are the last person to blindly follow in the wake of that impotence and deadness of taste which…is rapidly crushing and starving American industrial art…. I believe you are losing the great opportunity for your own institution and for the cause of art in America.[127]

In the battle of wills and rhetoric, the young Frederic Pratt was considerably outclassed. He meekly retracted his dismissal and replied, "my letter to you was meant to be more in the line of question and suggestion than as positive decision, though as I look it over now, I can see that such was the statement."[128]

Pratt had partly won the financial battle, though, since Dow agreed to a salary which was less than Fenollosa was being paid for merely "supervising" Dow and delivering occasional lectures. His first, "The Value of Japanese Art as Measured by Universal Standards," took place on October 31, 1895. Fenollosa's association with Pratt was to be short-lived. Although he would continue to lecture infrequently, his appointment was officially terminated in March 1896 after news reached Frederic via Perry and Clark about his divorce and remarriage to his assistant at the Boston Museum of Fine Arts.[129] Because of this scandal Fenollosa also lost his job in Boston; he and his wife sailed for Japan in April.

Teaching Composition

FREDERIC'S DECISION to employ Dow would have richly rewarding consequences. The relationship between Dow and Pratt, at a time when the Arts and Crafts movement was ascendant, proved to be symbiotic. Dow's ideas corresponded with the educational philosophy at Pratt, although his implementation was directly opposed to Perry's academic system. During his years at Pratt his new "synthetic" instructional method would be integrated with the curriculum to more effectively unify the training of fine and applied artists. Like those at Pratt, he not only believed in a broader definition of art which extended to design, but he saw in this the basis for a democratization of art education. He wrote to Frederic on September 12, 1895, just before beginning his new duties at Pratt:

The cause to which I devote enthusiastic support is the education of the artistic faculty—the endeavor to give pupils a stimulus to produce strong original work—to start them in a line of thought and study which shall enlarge their powers in any field of art which they may choose—whether they paint pictures, design wallpaper, or hammer iron, their sense of beauty can be so quickened that they will of necessity make their work art. This bringing art into *life* is, as I understand it, one of the great aims of Pratt Institute.[130]

As this declaration suggests, Dow also subscribed to the principle of "power, not knowledge." His teaching method, based on a system of graded exercises, was conceived to develop the student's aesthetic judgment rather than to train technical skills. In a virtual paraphrase of Charles Richards, Dow had stated in an earlier Boston lecture that the teacher's objective should be to develop the student's "art faculty" which, once possessed, "never retreats." "We lose other things—our Greek, mathematics—or skill in some craft—but when we once appreciate a work of art—once really feel its beauty we have moved a step on a track that leads forever upward."[131] Dow's de-emphasis of technique was a corollary to his disparagement of mimetic realism in painting. Like Perry he believed that all good art was a reflection of thought, maintaining that "a pictorial composition is not merely an assemblage of objects truthfully represented, it is the expression of an idea."[132]

Unlike Perry, however, this conviction led Dow to dismantle the academic system, which he described as the "teaching of art through imitation…gathering [a] knowledge of facts but acquiring little power to use them."[133] Dow knew this method firsthand, having studied at the Académie Julian in Paris. The experience left him "in a state of revolt against the meagerness of the instruction."[134] He responded by supplementing his education with evening classes at the École Nationale des Arts Décoratifs. Encounters with Japanese prints and art by Gauguin and his circle would also be formative

to his future development.[135] Dow faulted the academy because it devoted years to teaching students how to draw "maps of human figures" with scant instruction offered on principles of composition. In his opinion this was where creativity and artistry came into play. He defined composition as "design" or "structure"—"the putting together of lines, masses and colors to make a harmony."[137] More than empty formalism, however, composition was "the expression of an idea," "the very act of making visible a mental image," and thus conveyed the artist's own personal interpretation and feeling for beauty.[138] Max Weber, one of Dow's students at Pratt, echoed him years later in an essay on photography: "In our choice and elimination lies the very character of our personality, the very quality of our taste and expression."[139]

The task of the teacher, according to Dow, was to develop each student's perception of good aesthetic design. This endeavor paralleled Perry's and Hopkin's mission to instill an understanding of beauty. For Dow, however, Japanese art and culture represented the most compelling standard. He asserted that in Japanese art "composition is omnipresent. It is a part of Japanese life, and is manifest wherever there is use of lines and colors, and contrasts of tone, be it a picture…or an ornamental cup, the spray of flowers in a vase, or a landscape garden. It is the essence of their acting and dancing, of their manners."[140] Examples of Gothic and early Italian Renaissance art could also be fruitfully studied. At Pratt Dow used Japanese prints and the collection of photographs as part of his instructional tools.[141] Among contemporaries, he especially admired the work of Whistler, Puvis de Chavannes, and Manet, sending his students off to the Metropolitan Museum of Art to study Manet's *Boy with a Sword*.[142]

For Dow, a pedagogical system based on composition had two other essential benefits. Composition, as he defined it, applied to the crafts as well as the fine arts, providing a common foundation for both. By contrast, academic training, inherited from the High Renaissance, had severed

that unity by dividing painting and drawing into two branches—representative and decorative.[143] Concurrently, the academic system also established an elitist studio tradition which excluded both the craftsman and the ordinary individual.[144] The facility to recognize good design, however, required no innate talent or cultivated skill, and therefore could potentially be grasped by everyone, including children. Dow termed this an education of "appreciation," writing that "the study of composition means an art education for the entire people, for every child can be taught to compose—that is to know and feel beauty and to produce it in simple ways. The artist, to be a public educator, must turn away from so much realistic easel painting and through design and decoration bring beauty into everyday life."[145] As Joseph Maschek recently observed, Dow put the matter of form on the kitchen table. Again, the Japanese were trendsetters: "art in the East is a part of the people's life, because the art education is one of appreciation as well as production."[146]

Dow's method of teaching was based on a series of graduated exercises using comparative techniques to sharpen the student's judgment, nurture his artistic instinct and "train the hand to express that which the mind feels."[147] By continuously exercising choice and judgment, the student developed his creativity and the ability to draw. This process, in which aesthetic decisions are made based on informed personal response rather than copying from models, conforms with Froebel's pedagogy of self-activity. Dow wrote that a work of art requires "the student's personal interpretation or idea of…beauty…the way he sees it."[148] He explained his approach in articles in the *Pratt Institute Monthly* and in his book *Composition*. Beginning with abstract straight lines, the pupil was asked to experiment with different arrangements and then choose the one he felt to be the best. As soon as he recognized that "straight lines crossing at right angles may express beauty, the application follows—plains, or a landscape where tall tress cut the horizon."[149] When the student had

Ando Hiroshige, *Narumi Station, Travelers Passing a Row of Fabric Shops*, from the *53 Stations of the Tokaido* series. c. 1833-34. Dow owned a set of these prints.

45

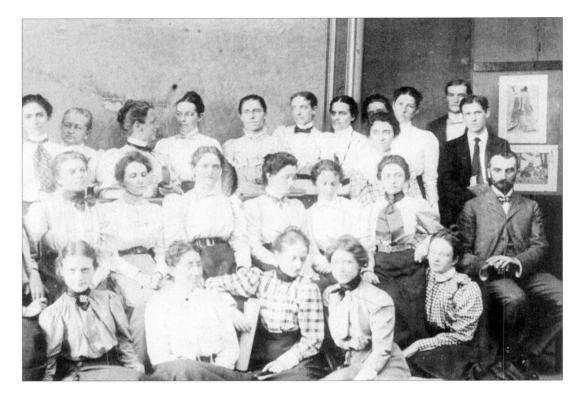

Top: Arthur Dow with class at Pratt, 1899. Japanese prints hang on the rear wall.

Left: "Elementary Exercises in Art Study" by Dow students at Pratt illustrated in the *Pratt Institute Monthly,* April 1900, p.133.

Right: Arthur Wesley Dow, *Composition,* first published in 1899.

COMPOSITION

A SERIES OF EXERCISES SELECTED
FROM A NEW SYSTEM OF
ART EDUCATION
BY

ARTHUR W. DOW

Instructor in Art at Pratt Institute and at the
Art Students' League of New York

ΣΥΝΘΕΣΙΣ

PART I
FIFTH EDITION
NEW YORK
THE BAKER AND TAYLOR COMPANY
33 East Seventeenth Street
1903

mastered linear composition, he progressed to *notan* (a Japanese term adopted from Fenollosa referencing the flat distribution of light and dark), and finally to color.

Essential to the process was the creation of ordered and unified spatial relations. Dow wrote repeatedly about the importance of "filling space" and of lines "cutting space" in harmonious ways, insisting that spacing is the very "groundwork" of design. He articulated five principles for "arranging" space: opposition, transition, subordination, repetition and symmetry. To develop the student's ability to design, he would have them enclose drawings in different "frames"—rectangles or circles—in order to study their effect and make the necessary adjustments to maintain a well-proportioned composition. This produced results similar to the croppings of Japanese prints or photographs. [150] Students were always required to evaluate their results against examples of earlier art provided by Dow in the form of Japanese prints, photographic reproductions, textiles and Indian basketry from the Pratt collection. [151] Student designs adapted from the fabrics were later used as illustrations in *Composition*. Pupils were encouraged to analyze and copy art according to linear structure and tonal patterns ("spotting"). Dow's comparative methods, perfected in Pratt classrooms, were incorporated in *Composition* where he demonstrated the universality of good design principles by juxtaposing examples of art from different mediums and cultures.

Dow's Revolution at Pratt

THE HIRING OF Dow and Fenollosa was proudly announced in the October 1895 issue of the *Pratt Institute Monthly*. The notice, written by Perry, stated that new instructors had been added because "the Trustees…believe that the study of art means more than drawing, and that one of the highest gifts is creative ability, which should be encouraged and developed." In conclusion he added that more attention would be given to teaching "the fundamental principles of composition and design." [152]

Perry had already been moving tentatively towards an expansion of his academic curriculum. In the 1894–95 catalogue he inserted a new sentence into the description of the "Regular Art Course," acknowledging the "study of composition" as "a very important feature of the whole course…" In a department report that winter he emphasized the broad diversity of the classes, observing that "to sit before a white cast, day after day, and month after month…perusing this one line of work without variation…is mechanical." [153] He went on to discuss the "fatigue point" of such work which drains the student of inspiration and the need for "parallel" lines of instruction. Nonetheless, Dow's techniques were incorporated gradually into the curriculum, engendering unease among the faculty. Perry, in particular, remained concerned that Pratt would not remain competitive with other schools if they altered their course offerings. Dow's "synthetic" exercises proved successful, however, winning over anxious students. By the end of the first year he was allowed to drop the class in life drawing and expand his composition courses. Because of increased demands placed on his time, the school hired Hugo Froehlich as his assistant. [154]

Perry summarized the year in his June 1896 Art Department report:

> Upon the opening of the fall term many changes were made…and it was with much hesitation that the new lines were introduced because of the wide difference in character from what is being pursued by other art schools. The anticipations also were that many students would leave the classes. However, the new work was begun with the feeling that when thoroughly understood, it would attract a larger number of students.
>
> The effort has been made to have the students reach beyond mere technique and realism to idealism…. His [Dow's] work has been watched with much interest. At first the students were skeptical regarding it, but as the work progressed it was greeted with increased enthusiasm which was maintained and

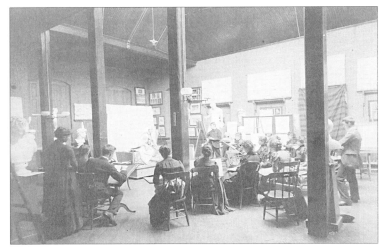

Drawing from the
model.

course combining drawing, painting and composi-
tion. Students first worked from a costumed model
under the instruction of Ida Haskell, then incorpo-
rated the figure into an original composition under
Dow's supervision. Perry reported that pupils and
teachers were both enthusiastic over the change.[158]
During the next few years Dow also introduced
special advanced classes in composition. In 1899 he
offered a course in which "much attention was
given to drawing from reproductions of the work
of old masters, a similar rendering being applied in
drawing directly from the model and introduced
into pictorial compositions."[159] Examples of his stu-
dents' work, selected by Dow, were frequently
reproduced as illustrations to his articles in the
Pratt Institute Monthly.

Dow's spirit permeated the school by the end
of the decade. A report on the activities of the
High School, for example, discussed watercolor
classes taught by Miss Emma Brill: "After several
general lessons the students copied from Japanese
prints. During the spring months flowers were used
in design filling required spaces."[160] High School
students composed plaids (Dow's abstract linear
studies) and worked from textiles. Perry also had
appropriated many of Dow's ideas, incorporating
them within his own vision of Pratt's mission. His
1901 summary of art department activities dethroned
academic study in favor of more varied training:

> To become the perfect draughtsman of the
> human form does not alone constitute an art
> education, yet this aim has too long been the
> sum and substance of art training in many
> schools...academic training without parallel
> training from the first in creative work and an
> appreciation of the best in art and design stul-
> tifies and deadens the faculties to such an
> extent that the young would-be artist can
> rarely branch out into original work upon the
> completion of his five years of technique.[161]

An integrated art and design education
remained paramount, fostered by the inclusion of
composition classes within the required first year

strengthened to the end of the year. Everything
has been done to develop individuality on the
part of the student...More and more inquiries
have been made regarding the work of Mr.
Dow by parties outside the Institute.[155]

National recognition followed shortly in an
editorial for *The Lotos* by Fenollosa, praising
Frederic Pratt and Dow.[156]

Although Perry referred to implementing
"decided and radical changes from the methods in
vogue in New York art schools and elsewhere," the
catalogue indicates an integration of the previous
courses with composition classes now required for
students in the Regular, Design, and Normal
schools. A year later, in 1896, Dow contributed an
essay, "Composition," to the catalogue which was
inserted between program summaries of the design
and architecture degrees. He emphasized that the
study of composition was to foster creativity, indi-
vidual expression, and "an appreciation of the
beautiful."[157] By 1898 Dow's comments were includ-
ed within the general introductory statement for
the School of Art and Design. Additional curricular
changes were implemented that year, separating
Pratt further from other art schools. The decision
was made "with some anxiety," according to Perry,
to reduce the weekly all-day portraiture class to
once a month. In its place, life classes were held in
the morning, with afternoons reserved for a new

program. In these, all pupils progressed through the same exercises, learning the principles of line, form and color by drawing landscapes, insects, and flowers. (The school owned a conservatory on Clinton Avenue.) Even in later specialized studies, interrelationships were foregrounded. Thus, Otto Beck, an illustration teacher hired in 1901 from the Art Academy of Cincinnati, wrote that "composition for the illustrator should begin with surface decoration. The printed page is subject to the laws that underlie design as practiced today."[162] At the same time, Dow's advanced composition courses also included fine arts—as well as design—majors. He wrote that the "main subjects for his class are color harmony, landscape painting, mural decoration, illustration with use of life model, composition of figures with landscape, techniques of oil painting, and advanced design."[163]

Dow's egalitarian vision was given ample range at Pratt where he taught not only in the art department, but also in the high school and the kindergarten teacher training program. By far his greatest impact on national art education came via the hundreds of Normal School students who disseminated his methods through the country. Dow graduates were especially numerous in New England and the Midwest. His system was incorporated into the Detroit public schools by 1906, in the Laboratory School at the University of Chicago, and in the curriculum for the School of the Art Institute of Chicago.[164] Through Ralph Johonnot, a design colleague at Pratt, his methods were transplanted to San Francisco and Pasadena. Dow gained additional publicity through the Prang Educational Company which sponsored a travelling show of his students' work in Chicago in 1900. Later editions of Prang's *Teacher's Manual* by Perry, Clark and Hicks revealed the influence of Dow through quotations from his writings, illustrations of Japanese art, and design studies by Pratt students.[165]

By 1899, after the completion of *Composition*, Dow was increasingly on the lecture circuit and tempted by job offers (he did teach courses at the Art Students League from 1899-1903), while articles

on his pedagogical system appeared frequently in art magazines and newspapers.[166] A reporter for the *New York Herald* wrote, "probably no branch of work in the institute is better known throughout the country than the system of instruction in composition and design under the supervision of Mr. Arthur Wesley Dow."[167] With hindsight, Herbert Read wrote in *Education Through Art* that Dow effected a "new conception of art teaching" in America.[168] Pratt, for its part, achieved widespread recognition, gaining the reputation of being one of the most "progressive institutions," whose student work showed daring innovation and "superior training."[169]

For Perry, the most rewarding vindication of their risk-taking came in 1900 through an article on the Art Students League by Frederick Coburn in *Art Education*. Coburn, admittedly biased in favor of the Pratt-Dow system, praised the League for recent curricular innovations similar to those at Pratt, and criticized its previous insistence on conservative academic training. According to Coburn, this had failed to develop the student's imagination and had neglected areas of design and history. Coburn noted that the "drill theory" was finally being supplanted by the "development theory." Perry quoted the article at length in his department report, proclaiming triumphantly: "Nothing more strongly supports the methods of work carried on at Pratt Institute. We cannot but feel, therefore, that the work we are doing…is having a great influence upon other art schools. Emulation has taken the place of adverse criticism."[170]

The Pratt Gallery

WHILE THE DOW-INITIATED curricular changes had the greatest impact pedagogically on a national scale, it is arguable that the gallery exerted a more dominant force on the New York art scene. Through it Pratt created an identity as an institution closely linked with the artistic avant-garde. The gallery became a place where Robert Henri and his wife would brave a snowstorm to see paintings

by their friend Arthur B. Davies. Although Perry initially assumed his duties reluctantly, he soon threw himself into exhibition planning as the gallery achieved successes beyond anyone's expectations. During the years between 1894 and 1904 nearly sixty shows of fine and applied arts were held in accordance with a plan "perfected" in 1896.[171] Exhibitions open to the public, especially one-person shows, were not only a unique feature among art schools but also provided new cultural opportunities for Brooklyn, whose previous venues were limited to the Brooklyn Institute of Arts and Sciences and the Brooklyn Art Association. The latter organization, founded in 1861, sponsored semi-yearly member group shows and, occasionally, exhibits of French art until the early 1890s when it merged with the Brooklyn Institute.[172] As noted in a *Pratt Institute Monthly* review, "Residents of Brooklyn have so long gone to New York for art exhibitions that they have hardly yet accustomed themselves to thinking that there can be any pictures of unusual merit displayed in their own city."[173] Even in Manhattan, shows devoted to a single artist were more frequently held only in the atmosphere of a commercial gallery.

The twin rewards of educational value for the students and publicity for the school continued to motivate gallery activities. Whenever possible, circulars and announcements accompanied the exhibitions and were sent to an extensive mailing list of other schools, art societies, museums, dealers, and artists. Depending on funding, these brochures included essays, illustrations, and checklists. Reviews written by Dora Norton, a drawing instructor, and Perry were published in the *Monthly*, while the shows also enjoyed coverage in the New York press and, less frequently, in national magazines. Installation photos appeared in the *Monthly*, at the suggestion of Frederic Pratt, and in the school catalogues. In order to attract participants, the decision was also made in 1899 to permit sales transactions.[174]

Initially, exhibits of decorative arts and reproductive prints outnumbered those of prominent painters. Perry's contacts, beyond educators, were limited and it is unlikely that he would have been able to successfully solicit innovative or renowned artists.[175] Specific details documenting exhibition administration remain obscure because most gallery correspondence was not preserved.[176] However, it seems evident that younger faculty hired between 1893 and 1896 brought with them friendships that provided a base of operations. Dow, Frank Vincent DuMond, Guy Rose, Charles Curran and Henry Prellwitz, all of whom had their own shows at Pratt, were students in Paris at the Académie Julian during the late 1880s and spent summers in Giverny, Crécy-en-Brie or Pont-Aven. In France they met Theodore Butler and Robert Henri, among others. Acquaintances were also formed at the Art Students League where many studied and were later employed (Dow, DuMond, Reid, and Robert Blum).

Herbert Adams, who taught sculpture at Pratt, had worked in France and was, together with Henry and Edith Prellwitz, part of the Cornish, New Hampshire art colony.[177] Dora Norton attended summer classes with Charles Davis in Mystic, Connecticut. Many of the painters (DuMond, Henri, Blashfield, Blum, and Reid) were neighbors at various times in the Sherwood Building in Manhattan. Most probably, Henri's show was arranged through Davies, and Butler's through his friend Prellwitz.[178] Butler, however, also knew Adams, whose portrait appeared in Butler's show. Dow's contacts would also have been instrumental in securing exhibitions for his friend John LaFarge and, possibly, Robert Blum. Alumna Gertrude Käsebier was particularly well-connected and must certainly have been responsible for the impressive photography shows begun after 1900. Exhibits by her friend Clarence White were held in 1901 and 1904, and her student (and Dow's) Alvin Langdon Coburn in 1903. Additionally, Edward Steichen's paintings and photographs were shown in 1908.

Several of the Pratt exhibitions were travelling shows shared with other institutions. These included the exhibits of Henry and Edith Prellwitz, first seen at the Baltimore Charcoal Club in January 1899; Henri, whose show originated at the Pennsylvania Academy of Fine Arts in Philadelphia (November 1902); and Käsebier. Her exhibit, facilitated probably by Dow, opened at the Boston Camera Club in November 1896 and travelled to Brooklyn in February, where it was her first New York show. Butler's exhibit was repeated a month later in March 1900 at the Durand-Ruel Galleries in Manhattan. Pratt enjoyed collaborative relationships with both the Durand-Ruel and Macbeth galleries. Through Durand-Ruel, Pratt hosted exhibitions of French Impressionists Claude Monet, Henri Moret, and a group show which included paintings by Eduard Manet, Edgar Degas and Mary Cassatt. The Pratt family were friends and clients of fellow Brooklyn resident William Macbeth for nearly fifty years. The Macbeth Gallery was involved in several Pratt exhibits, beginning with the Swedish painting show in 1896 when they were contacted by Hopkins to repair broken frames.[179] William Macbeth also arranged the exhibits by Davies in 1897 and 1901, and the show of Old Master drawings in 1899.[180] Davies became a favorite of the Pratts, who bought many of his paintings. The Macbeth Gallery was additionally linked to the school because they represented several Pratt faculty, graduates, and artists who exhibited in the gallery, including Dow, Pamela Colman Smith, Henri, LaFarge, Howard Pyle, and Charles Volkmar.

By 1900, with the exhibitions of established painters like LaFarge, Blashfield, Davis and Blum having taken place, Perry could report with satisfaction that "while it has been a difficult matter to hold our position in consideration of what New York offers in this particular, yet we have reached the point where artists and others are glad to take advantage of the opportunities the gallery offers." He reflected:

It is with pleasure that the director recalls the many courtesies and generous cooperation attending requests for exhibitions in consideration of the fact that many have been extended by some of our most representative American artists who have given a part of their valuable time from a pure desire to be of service and have, in not a few instances, aided personally in the arrangement of their exhibitions.[181]

A review of the Charles Davis show in *The Artist* began: "In the splendid work which is being accomplished in the cause of culture by Pratt Institute, Brooklyn, frequent exhibitions play an important part," and a reporter for the *New York Tribune* noted that the LaFarge exhibit, which was extended for an additional twelve days, "has numbered among its visitors artists from other cities who have come to Brooklyn for the purpose of seeing this collection."[182]

Although the exhibitions were essentially "unplanned" according to any comprehensive vision—comprising whatever art or artist was available and interesting—nonetheless they were united by consistent objectives and artistic beliefs which repre-

ART STUDIES IN PHOTOGRAPHY
BY
MRS. GERTRUDE KÄSEBIER

An Exhibition on view in the Art Gallery of the Pratt Institute, Brooklyn, New York, Department of Fine Arts

February first to February thirteenth
1897

Announcement, of Gertrude Käsebier's exhibition, 1897.

Left: Basket with lid, Native American, Aleutian Islands, first quarter 20th century.

Right: Gertrude Käsebier, *Kills Close to the Lodge*, 1898. Käsebier's photographs of the Sioux were exhibited at Pratt in January 1899. They were part of a widespread interest in Native Americans at Pratt that included exhibitions and articles on Northwest Coast baskets and Navajo blankets. A delegation of Sioux from Buffalo Bill's Wild West visited the campus in the spring of 1898.

sented the philosophy of the school and the tastes of Perry and Dow. The exhibitions, taken together, could be viewed as Dow's *Composition* illustrations assuming three-dimensional life. Certainly a Japanese, or Asian, bias was evident through displays of Japanese prints, textiles and bronzes, Oriental rugs, the Prang lithographs for W. T. Walters' published collection *Oriental Ceramic Art,* Dow's woodcuts and drawings, LaFarge's watercolors from Samoa, Japan and Hawaii, and Blum's paintings and photographs of Japanese life. The Arts and Crafts ideology was embodied in displays of pottery by Rookwood, Grueby, and Volkmar, as well as Native American baskets and Tiffany glass.

Pratt's pedagogical orientation for training the craftsman as an artist informed Perry's goal of enabling the "visitor and student" to see "the application of art to manufactured products."[183] In circulars and reviews, the importance of creativity and individuality in the applied arts was reiterated. The pamphlet accompanying the Grueby exhibit began: "The Grueby Pottery is first of all an evidence that American Industrial Art is not completely enslaved to machinery and mechanical reproduction. The makers of this Pottery have gone back to the methods of the Egyptians and the Greeks; each piece being the handiwork of the potter and the artist and bearing the stamp of individuality."[184] Similar interpretations were provided for hand-woven rugs

and textiles. The circular for the Noorian collection of rugs proclaimed: "In this age of mechanical processes, in which machinery too frequently takes the place of artistic and creative handiwork, it is gratifying and inspiring to revert to the art productions of the earlier centuries in which individuality restricts only as it demands obedience to the laws of beauty governing form and color." For the benefit of the students, exhibits of rugs, glass, and metal work were accompanied by explanations of the historical development of styles and techniques.

Many of the decorative arts exhibits were loaned by companies who conducted business with the Institute or the Pratt family. Tiffany Glass and Decorating Co. had designed the interior of the Library Building; J & R Lamb provided signage for the school; and Frederic Pratt purchased glass and rugs from Tiffany and Joseph Wild & Co. to furnish his Brooklyn and Long Island homes. Efforts were also made to maintain links with commercial establishments that represented potential employment possibilities for the students. Graduates, for example, were placed at Tiffany's and Rookwood Pottery. Pratt hired Tiffany designers Robert Hunter in 1894 and Joseph Aranyi in 1900 to teach metal chasing, engraving, and die-sinking; Charles Volkmar's son Leon taught pottery at Pratt.

More than any other factor, educational value provided a cohesive exhibition policy. This purpose was reflected in classroom visits to the gallery, interpretive texts in circulars and reviews, and supplementary lectures and workshops held in conjunction with the shows. F. Stymutz Lamb and C. R. Lamb spoke on "Glass Mosaic" and "Mosaic and its Possible Use in Modern Decoration"; Dow lectured on Monet in 1903; and second year design students were taken on a field trip to Tiffany's. Many exhibitions—textiles, woodcarving, tinsmithing, basketry, and book illustration, as well as the fine arts—complemented subjects taught in courses. Reviews in local papers repeatedly commented on the shows' "instructive" usefulness to students. The gallery's existence was itself testimony to a pedagogical belief—consistent with the object-

based principles of Pestalozzi and Froebel—in the importance of direct contact with art. The significance, and infrequency, of this type of learning experience was noted in an article in the *Brooklyn Daily Times:* "Such exhibitions are of extreme value in connection with art study. The average art student is apt to consider that his only study is to be obtained in the art school rooms…. As a rule, this line of study is ignored by teachers, and the Pratt Institute, by bringing these within reach of the students, is according unusual opportunities."[185]

Perry's didactic agenda also led him to curate exhibitions which revealed the artist's creative process. This resulted frequently in displays of rarely seen sketches and preparatory drawings that earned the gallery critical acclaim, especially in exhibits by LaFarge, Davies, Blashfield, and Blum. Perry's motives can be deduced from LaFarge's epistolary response:

> The sketches in crayon, pen and ink…have been taken out of my sketchbooks, with but few exceptions. They were meant absolutely for myself…and until now I had not considered the possibility of their being seen by others. It may be that from that point of view they might have the educational interest for which you asked me to loan them…. The drawings…for glass-work were chosen at random; only in a few cases could they explain my methods.[186]

The gallery's foremost objective was summarized by Norton in her review of Dow's 1899 show: "this exhibition is very properly and most effectively arranged to illustrate methods of work such as will develop and train the creative faculty."[187]

Perry's effort to document the evolution of an art work was most successful with mural painting. For Blashfield and Blum, the stages were recreated in chronological order from first sketches through clay figures and gridded perspectival studies to photographs of the finished murals. As explained by Norton, the student was not only able "to study the development of an artistic idea from its most elementary expression…to its final consummation

in a complete work of art" but allowed to be "taken into the confidence of the artist."[188] She elaborated these themes further in her review of Blashfield: "few have been privileged to examine the more personal notes in the form of sketches, color studies, and drawings that preface his various art achievements…. It is in the work of these spontaneous and formative moments that one comes into touch with the personality and methods of the artist."[189] Many of these studies were for prominent and much publicized murals, including paintings for the dome in the Library of Congress and for buildings at the Chicago World's Fair. In the case of Reid, whose exhibition was in November 1896, drawings allowed visitors to examine actual works in progress. His sketches of allegorical figures representing the five senses were for panels in the Library of Congress completed in 1897.[190]

Perry's other guiding curatorial principle was diversity, both in medium and style. He wrote that "no time has been spared by the director to secure

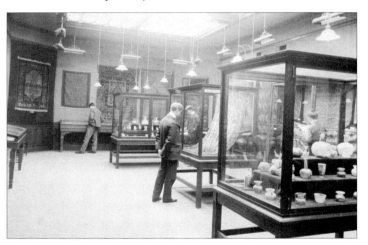

"Iridescent Glass, Brocades and Rare Oriental Rugs," exhibition, April 1900.

variety in the exhibitions in the Art Gallery, in order that visitors and students may see many methods of work."[191] Robert Reid's show introduced this direction, encompassing the multiple styles and purposes of Impressionism, academic realism, mural and easel painting, and illustration. In this light, John LaFarge may be regarded as the quintessential "Pratt" artist whose career evidenced

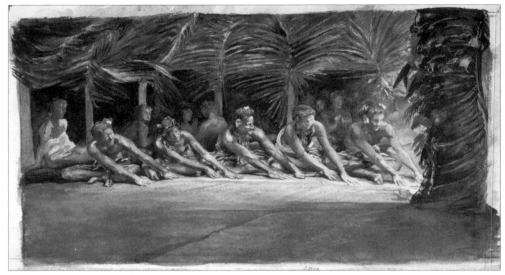

John LaFarge, *Sitting Siva Dance*, 1894.

the rich rewards of combining the fine and decorative arts under the inspiration of a Japanese muse. Certainly no greater stylistic range could have been presented to the Pratt student than the (nearly) back-to-back exhibits of Charles Davis and Theodore Butler—a fact noted in local reviews—or Henri Moret and Arthur B. Davies.[192] Perry observed that "together they form an admirable illustration of the diversity possible to art," contrasting Davies' poetic symbolism with Moret's impressionist celebration of nature.[193]

Despite a commitment to showcasing many different artistic options, a consistent aesthetic position emerged in reviews which could be traced to Perry's and Dow's shared dislike for mimetic realism and "mere" technical skill, already noted in their pedagogical writings and methods. This led to a preference for artists who, in their opinion, jettisoned the facts of visual appearance to convey ideas and essence. Frequently this resulted in support for more innovative or modernist painters who employed flattened forms or abstracted visible brushwork. With this aesthetic yardstick, Perry — or his spokesperson Norton—could champion such divergent painters as Davis and Henri. Thus, Henri was praised for his ability "to express his thoughts in simple and eloquent terms, eliminating details and concentrating upon the vital and philosophical truths that nature discloses to those who penetrate below the surface of things," while Davis was lauded for "penetrat[ing] beneath the surface of realistic

impression, seeing with the invisible eyes of the soul, and interpreting with the tender feeling of a true poet of nature."[194] Dow's paintings were also appreciated for similar reasons: they were "ideal nature," not "literal transcripts."[195] Similar beliefs were advocated at the Macbeth Gallery, undoubtedly enhancing the close working relationship with Pratt. An article in *Art Notes,* for example, criticized French salon painters Bougereau and Bonnat for their "sterility of bare knowledge…proving… that there is nothing satisfying or enduring in what is only artificial, clever, or after an exact set of rules and laws…it shows that the time is ripe for the production of pictures that embody ideas, that will make us think, and carry us beyond… mere execution…."[196]

The haunting images of Arthur B. Davies especially evinced this aesthetic and, more than others, he became a favorite at Pratt. His paintings were admired by Dow and Fenollosa, receiving favorable mention in a *Lotos* article, and he was a good friend of Käsebier, who acknowledged, "I worshiped his work and bought some of his pictures…He often came to see me."[197] The Pratt family also purchased several paintings by Davies, some of which were included in his 1901 exhibit at the school. For his part, Davies acquired two works from Pratt student Max Weber at his first American show. Davies' dreamy symbolist pictures, bordering on Tonalism, were not unrelated to the early landscapes of Dow, who shared his interests in art and

music, and to the work of Davis. His mystical-mythical leanings and Old Master influences further endeared his paintings to Perry, who praised their ability to convey "spiritual significance" and the "inner thought of the artist," rather than "facts." Perry declared: "In this age of realism, these creations of beauty and significant expression form a rare and welcome contrast;" they "bring to souls wearied by the tedium of every-day existence, refreshment and delight."[198]

Admiration for Davies also extended to Puvis de Chavannes whose flat decorative style inspired Davies. Dow and Fenollosa championed the later career of Puvis in this country, lobbying on his behalf to secure the Boston Public Library commission. Articles on Puvis were published in the *Monthly* (January 1899), and prints of his Boston murals, as well as those by Sargent and Abbey, were exhibited at Pratt.

The bias against factual realism resulted, somewhat unexpectedly, in an endorsement of photography, valued for its degree of artistic expression. Dow led the way with his article on Käsebier in *Camera Notes.* Beginning with the opinion "that there are two ways of looking at a picture—one as a record of truth, the other as a work of fine art," he concluded that her photographs were successful because "she chooses the artist's point of view, that a portrait is not a mere record of facts."[199] This orientation shaped the increasingly enthusiastic reviews of photo exhibitions at Pratt after the turn

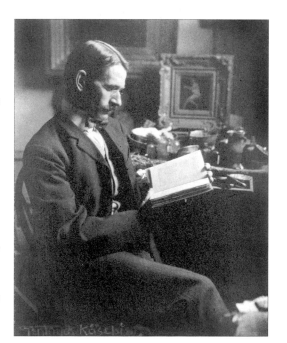

Gertrude Käsebier, *Arthur B. Davies,* 1907. This photograph was one of several taken by Käsebier of members of The Eight (The Ash Can School) to illustrate an article in the *Craftsman* publicizing their 1908 exhibition at the Macbeth Gallery.

of the century. Coburn and White were admired for their mastery of form and their ability to express ideas, just as in the best of paintings. The writer discussing White's second show in 1904 remarked on the "astonishing gain" since his 1901 exhibit, citing his "magnificent sense of composition," and proclaiming:

> With all this, we find a most consistent individuality—the free expression of an artist's conception—possible only through means perfectly subject to his will. Barring actual color, the aim and the ends achieved are identical in character with those in all great paintings.... All of this indicates that photography must, in future, take its place as a subject for serious artistic study; ceasing to be, as now, literal representation, and becoming, as Mr. White has made it, interpretive representation and a fine art.[200]

Many exhibitions at the Pratt Gallery represented significant accomplishments apart from their educational value within the context of the school. Critics cited the contributions of shows which displayed works previously unseen or which

Arthur B. Davies, *The Source,* 1896.

Robert Henri, *The Man Who Posed as Richelieu*, 1898

Robert Blum, *Figure Studies: Head, Nude and Draped Figure*, n. d.

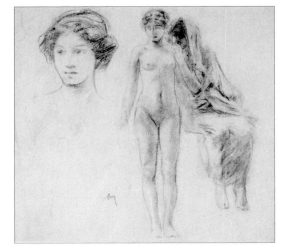

afforded opportunities for young painters such as Henri, Butler and Davies who were often excluded from more conservative venues. Fitzgerald, in reviews for the *Evening Sun* (December 27 and 31, 1902), applauded Henri's show, noting "the number and variety of the pictures, many of which have not been seen in public hitherto," and stating that "an exhibition like this is highly stimulating after the perfunctory exhibitions of the ordinary sort. The distinction is not merely superficial." Pratt also garnered praise for presenting drawings by Blashfield, Blum, LaFarge, and Davies. Blum's show was considered a particular triumph because he exhibited infrequently and had not been given a one-person show, except for a brief display of his mural *The Vintage Festival* together with preparatory drawings in September 1898 at the National Academy of Design. After 1894 he had ceased to participate in the group shows at the National Academy of Design, the Society of American Artists, and the American Water Color Society. One reviewer observed that "the Brooklyn public is...thus offered an unusual opportunity to study at leisure these admirably artistic productions, for

Mr. Blum's work is, alas, too seldom seen by itself."[202]

Davies' January 1898 exhibit was especially important because it included his drawings for the first time. This achievement was noteworthy in view of his reluctance to part with them. "Friendly" reviewers believed that the sketches answered previous criticisms about his draughtsmanship in painting:

> He is not over squeamish in the matter of anatomical truthfulness and balance, and he does not hesitate to take liberties with the human form, nor does he always maintain a high standard of female loveliness, as judged by the accepted canons of beauty. But he dares much and he has the courage of his convictions.... A number of the drawings here show this conclusively.[203]

A statement prepared by Perry for the *Brooklyn Daily Times* directly addressed this issue:

> These drawings are exceedingly interesting, both because they are calculated to silence in a measure Mr. Davies' critics, who, while they have been cordial in their appreciation of his color work, have been very critical of his drawing, and also because they will have an opportunity for an intelligent and satisfactory study

of his methods and ability.[204]

In at least two other cases—with Dow and Butler—Pratt articles responded defensively to published attacks. Butler's reception by New York critics was quite hostile, with even favorable reviews declaring: "If the trustees of this institution are trying to give art students examples of all kinds of art treatment they have found an extremist in Mr. Butler."[205] Norton replied positively, explaining his use of "pure and light prismatic colors," referred to by others as "crude" and "mad," and offering advice to the gallery visitor:

> In this attempt much must be sacrificed. As in the case of any pioneer, the work often shows the struggle in ruggedness and even crudity. Nevertheless, if one can lay aside preconceptions and expectations and enter into the aim and spirit of the artist, one may enjoy in the pictures of this school's marvellous effects of light and atmosphere generally deemed untranslatable by the brush. In this attitude of sympathetic inquiry the thirty-two paintings by Butler… could best be seen…. He is one of the most sincere and conscientious of modern artists.[206]

Norton's article on Dow's 1899 exhibition seems to have been even more pointedly directed at a negative review which referred to his paintings as unfinished: "mere ébauches…empty to a painful degree."[207] In apparent response, Norton wrote, "By very simplicity, by largely rejecting limitations of detail, by incompleteness of information, the true masterpiece both provokes the imagination and sets it free to work."[208]

New Directions

PRATT INSTITUTE underwent significant changes between 1902 and 1904 which altered the direction of the school and brought to a close the Arts and Crafts era. The gallery continued to mount exhibitions until World War I, although shows of significant artists became less frequent. By 1904 the Trustees had voted to close the high school as of spring 1905. This decision was made because, according to Frederic Pratt, a new manual training public high school in Brooklyn had rendered it unnecessary.[209] Until 1903 the Institute remained aligned with the Arts and Crafts movement. Articles in the *Pratt Institute Monthly* appeared on Native American baskets and blankets, handweaving in North Carolina, and "Village and Peasant Industries," which discussed the British Guild and School of Handicraft and the Massachusetts Deerfield Society of Blue and White Needlework. The Domestic Science department had by this time (1899) begun to form its own collection of crafts. The "Annual Report of the Department of Fine Arts" for January 1902 included a special section, "The Arts and Crafts," which described plans to install cases in a room for the display and sale of students' craftwork. This was done in anticipation of the formation of a graduate students' "Arts and Crafts Guild."[210]

The Annual Reports for both January 1902 and 1903 continued to stress the importance of fine arts instruction in the Normal Art and Manual Training courses. Applicants were judged on their portfolios because "artistic ability must also be included in adaptability for the work. The manual training of the future must be along the line of the Arts and Crafts, and no longer confined to mechanical skill alone." In keeping with the reality

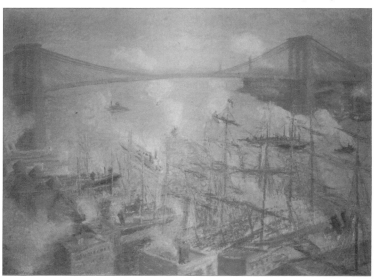

Theodore E. Butler, *Brooklyn Bridge*, 1900.

that "more and more attention is being given to the Arts and Crafts throughout the country," Pratt offered courses in leather, textiles, basketry, weaving, woodcarving and metal arts.[211] Emphasis was placed on comprehensive learning integrating both design and execution, believing that: "the knowledge that comes through practical application is of the utmost importance in the vitalization of the design and in acting as a stimulus to the creative impulse."[212] Crafts made by Pratt students earned increasing praise from outside the school and were featured in an illustrated article for *Art Interchange* (February 1902).

During 1903, however, Frederic Pratt took unexpected steps to eliminate the Arts and Crafts orientation, severing the union between the artistic and industrial. His actions came at a time when Perry was away on a six-month sabbatical (January to September 1903) and the department was further disrupted by the resignation of Dow's assistant, Hugo Froehlich, to take a position with the Prang Company. One of the earliest indications of Pratt's plans appeared in a letter to Perry prior to his departure. In a discussion of the applied arts classes Pratt stated: "Such technical courses, I feel, represent the type of work for which the Institute should stand.... We must offer work of such a character that it will attract students who wish it for professional use and will win the confidence and cooperation of the manufacturers."[213] Soon after this he wrote to Perry about student dissatisfaction with the interior decoration class: "It seems to be the old difficulty of the 'trade conditions,' which our course doesn't entirely meet; and the desire of the students to get quickly into some kind of work which will bring returns from a money standpoint."[214]

Pratt's pro-industry view on this issue, debated ten years earlier in correspondence with Fenollosa, would still have been censured by Fenollosa and Dow who had not altered their position. Dow's teaching remained in direct opposition, where "technical considerations of availability for commercial purposes count for less than qualities of

imagination."[215] Fenollosa had recently delivered a paper, "The Possibilities of Art Education in Relation To Manual Training," at the 1902 meeting of the National Education Association, and Dow was increasingly involved with teaching crafts (pottery, metal-work, textiles) in his Ipswich summer classes. It is tempting to speculate whether Frederic's new opinions may have been influenced by conversations and correspondence with Andrew Carnegie. Pratt and Carnegie were frequently in touch during these years when Pratt Institute served as a model for the Carnegie Technical Schools (later the Carnegie Institute of Technology) founded in 1905. Carnegie delivered the commencement address at Pratt that same year.[216] Dow was certainly aware of Pratt's changing attitudes. Frederic had written to him in January about "the future of the Arts and Crafts movement in its connection with our work here," and had included Dow in a delegation of faculty who visited the offices and factories of several New York "professional designers and craftsmen."[217]

By June Pratt moved decisively to reverse the direction which he had himself initiated by hiring Dow and Fenollosa. He reported to Perry abroad:

> The new catalogue will show a number of changes both in subject matter and in arrangement [pottery classes were eliminated; art metal and woodcarving became technical courses with design taught separately].... I have left out of the catalogue all reference to the arts and crafts either as a course of study or a subject in a course. There is considerable reaction, at the moment, not only against this term, but against the work for which it stands and I feel that we should be in the lead to give it up, as we were among the first to assume it, when we felt it was going to develop into work worthy of your department. The reaction is also felt in manual training work, and I feel that in our manual training we cannot be too conservative in our design or too careful in our technique. In place of the arts and crafts work

which we have been doing in manual training, has come a tendency,—with which I am not in entire sympathy,—to introduce the primitive arts and industries.

Mr. Richards, I understand, has quite thrown over his old ideas of manual training and is now taking up the subject from the standpoint of the industrial arts, associating it with primitive industries, on the one hand, and the creative arts, on the other. In this unsettled state, I believe that we cannot move too slowly or study too carefully into the situation, before starting out in a new line. This partly explains my hesitation in appointing a permanent man to succeed Mr. Froehlich.[218]

The "primitive arts" to which he referred were used in teaching not only by Richards but by Dow at Ipswich through a method where the "student goes back to the primitive beginnings of an art, and is shown how to put himself in place of the ancient worker" so that he will develop his work "according to natural indications and without…sophistication."[219]

Pratt's new plans, at odds with Dow's beliefs, must have contributed to his decision to leave the school in December 1903 when he accepted the offer to become Director of the Department of Fine Arts at Teachers College, Columbia University. Dow's letter of resignation was sent while he was in the midst of a one-year sabbatical world tour (1903–1904), taking him to Japan, India, Egypt and Europe. He wrote to Frederic from Kyoto on December 6, explaining that Columbia had approached him before he left, but that he had only recently made up his mind. Despite their differences of opinion, both men seem to have experienced a keen sense of loss. Dow acknowledged: "I realize deeply what Pratt Institute has meant to me and to my work during the past eight years, and shall ever be grateful for its influence on my career. In a far more personal way I am humbly grateful to the Founder of the Institute for his ever living benediction, and to his sons for their constant consideration and human sympathy."[220] Frederic responded, referring to the news as:

> …a tremendous shock to us all.…I find it difficult to put into words my sense of personal loss. I have been interested in you and in your work ever since we first met; and I have valued the inspiration you have been to me and the wonderful influence you have exerted throughout the whole Institute.
>
> It is a satisfaction to feel that we have had so many years of your life and to know that,—no matter where your work may be done,—we can depend on your loyalty and cooperation.[221]

Following Dow's departure, his composition class was eliminated from the curriculum, and his statements removed from the catalogue. The Art Department report for December 1903, which featured the "general" (previously titled "regular") course and illustration classes, indicated that Perry was already expanding the life and portrait classes.[222] Published in the *Monthly*, the report was illustrated with student life drawings. Frederic's decision, which seemed inexplicable at a time when the Arts and Crafts movement was enjoying its greatest popularity and success in this country, again proved prophetic. Pratt's re-orientation placed it in the vanguard of art schools, anticipating by several years the new trend separating art and industrial-vocational education which emerged in the period immediately preceding World War I.[223]

—Marsha Morton

Endnotes

1. Editorial in the *Pratt Institute Monthly*, October 1892, 1, 2.

2. Walter Perry to Isaac Edwards Clarke, December 15, 1891. Published in Clarke, *Art and Industry. Education in the Industrial and Fine Arts in the United States*, Part III (Washington DC: Government Printing Office, Department of the Interior, U.S. Bureau of Education, 1897), 472.

3. "Pratt Institute, Brooklyn, N.Y.," *Scientific American,* October 6, 1888, 210–214. The article was accompanied by twenty illustrations depicting the various departments. Carnegie applauded Charles Pratt's generosity in two articles: "Wealth," *The North American Review*, No. CCCXCI, June 1889, 661, and "The Best Fields for Philanthropy," *The North American Review*, No. CXLIX, July 1889, 687. Carnegie visited the school in the spring of 1890 and remained in close touch with Frederic Pratt after 1900 while he was formulating plans for the Carnegie Institute of Technology.

4. Quoted in Charles M. Pratt, "Founder's Day Address," *Pratt Institute Monthly*, October 1893, 33. This was Baedeker's first guide to the United States.

5. "What the Department is Doing for Its Students," *Pratt Institute Monthly*, June 1893, 259.

6. "Pratt Institute as a Memorial," *Pratt Institute Monthly*, October 1892, 5, and Katherine E. Shattuck, "Art in the School Room," *Pratt Institute Monthly*, May 1898, 246. Shattuck was an instructor in the art department.

7. Early biographical information on Charles Pratt is contained in essays published in the *Pratt Institute Monthly* (October 1892 and October 1896), and a letter written to Clarke for his study *Art and Industry*, 450–451. By the 1890s Walter Perry (Director of the Art Department) was already mythologizing his friend who emerges in Perry's writings as a folksy paternalistic benefactor. Perry's history of Pratt was published in 1926, *Pratt Institute: Its Beginnings and Development* (Brooklyn: Pratt Institute). Additional information is contained in *Charles Pratt: An Interpretation* (Brooklyn: Privately printed, 1930), which includes essays by his son Frederic B. Pratt and Charles Richards (Director of the Department of Science and Technology). In 1988 a history of Pratt was written by Margaret Latimer but the manuscript, "A Field of Influence: A Centennial History of Pratt Institute," remained unfinished and unpublished. References to Charles Pratt appear frequently in books on John D. Rockefeller. For the most recent see Ron Chernow, *Titan: The Life of John D. Rockefeller, Sr.* (New York: Random House, 1998).

8. Charles Pratt to Isaac Clarke, October 25, 1888, in Clarke, 450.

9. Ibid.

10. He was also influenced by the book *Industrial Education* by Sir Philip Magnus (London: Kegan Paul, Trench & Co., 1888) which he purchased on his trip abroad with his son Frederic in 1889. An annotated copy is preserved in the Pratt Institute Archives.

11. Pratt to Clarke, October 25, 1888, in Clarke, 450.

12. Clarke, 453. Clarke contrasted this favorably to other schools, proclaiming it "a distinct step onward in the march of civilization." He also noted two other conditions as praiseworthy: Pratt would provide training absent in the Brooklyn public schools and equal provision had been made for educating girls as well as boys.

13. "Articles of Incorporation," Section 7, May 19, 1887, quoted in Clarke, 451.

14. For information on Cooper Union see Gail S. Davidson, *Training the Hand and Eye: The American Drawings and the Cooper Union* (New York: The Cooper-Hewitt Museum, 1994), and Edward Mack, *Peter Cooper: Citizen of New York* (New York: Duell, Sloan & Pearce, 1949). By 1892 the library's collection already numbered 34,000 volumes, with a membership of 16,500 and a circulation of 146,852 books. (See *Catalogue Pratt Institute*, 1892–93, Brooklyn, 68, 70.)

15. Discussions about the merits of manual training dominated the annual meetings of the National Education Association during the 1880s. For a thorough study see Charles Alpheus Bennett, *History of Manual and Industrial Education 1870 to 1917* (Peoria, Illinois: The Manual Arts Press, 1937). The movement was initially inspired by an exhibition of Russian instructional materials from the Moscow Imperial Technical School at the 1876 Centennial Exhibition in Philadelphia.

16. Adler's views on manual training are presented in his "Technical and Art Education in Public Schools as Elements of Culture," *The Journal of Proceedings and Addresses of the National Educational Association, Session of the Year 1884 at Madison, Wisconsin* (Boston: J.E. Farwell & Co., 1885), 308-318.

17. Charles Richards, "Manual Training - Where is the Root?" *Pratt Institute Monthly*, April 1898, 191, 192. Articles on these educators appeared frequently in the school magazine, while books by them were required reading for Normal School students.

18. John Ruskin, quoted in Eileen Boris, *Art and Labor: Ruskin, Morris, and the Craftsman Ideal in America* (Philadelphia: Temple University Press, 1986), 82.

19. This statement appears in the first catalogue, *Pratt Institute, Brooklyn, N.Y.* (Hamilton, New York: Fleming, Brewster & Alley, 1888), unpaginated.

20. Coy Ludwig, *The Arts & Crafts Movement in New York State 1890s–1920s* (Hamilton, New York: Gallery Association of New York State, 1983), 14-19.

21. Ibid., p.14. Wendy Kaplan gives the date as 1887. See Kaplan,'*The Art that Is Life:' The Arts and Crafts Movement in America, 1875–1920* (Boston: Museum of Fine Arts, 1987), 301.

22. *Pratt Institute, Brooklyn, N.Y.*, unpaginated.

23. These lectures were announced in the *Pratt Institute Monthly*, October 1892, 6–7. Jacob Riis spoke at Pratt in October 1895 and February 1896. His illustrated article, "The Lesson Taught Us by the Gang," appeared in the *Monthly* in November 1897, 39–45. Jane Addams, whose talk was sponsored by the Domestic Science Department, was at Pratt early in 1899. Notice of her lecture (without the exact date) appeared in the *Monthly*, March 1899, 131.

24. Eliot was frequently cited in articles by Pratt faculty and he lectured at the Brooklyn Institute of Art and Science during the 1890s. He wrote: "The main object in every school should be, not to provide the children with means of earning a livelihood, but to show them how to live a happy and worthy life, inspired by ideals which exalt and dignify both labor and pleasure." (See Kaplan, 301). While Charles Pratt was certainly invested in preparing students for jobs, he believed that both goals could be realized.

The development of Pratt Institute proceeded from a foundation provided by art activities in Boston, both in terms of the Arts and Crafts movement and educational initiatives. Charles Pratt, Walter Perry, Frederick Hopkins, Arthur Wesley Dow, Denman Ross, Ernest Fenollosa—all of whom were influential to Pratt—transplanted Massachusetts ideas to Brooklyn soil. For the best study see Marilee Boyd Meyer, *Inspiring Reform: Boston's Arts and Crafts Movement* (Wellesley, Massachusetts: Davis Museum and Cultural Center, 1997). The first essay is especially useful: Edward S. Cooke, Jr., "Talking or Working: The Conundrum of Moral Aesthetics in Boston's Arts and Crafts Movement," 17–31.

25. Richard G. Boone, *Education in the United States: Its History from the Earliest Settlements* (New York: D. Appleton, 1889), 228. He also recorded twelve manual training schools, twenty-eight technical schools with shops for practical mechanics, and thirty art museums, including several affiliated with colleges or libraries.

26. For information and a useful bibliography see Joyce Woelfle Lehmann, "Art Museum Schools: The Rise and Decline of a New Institution in Nineteenth-Century America" in *The Cultivation of Artists in Nineteenth-Century America*, edited by Georgia B. Barnhill, Diana Korzenik, and Caroline F. Sloat (Worcester, Massachusetts: American Antiquarian Society, 1997), 207–219.

27. A detailed history is provided in Arthur D. Efland, *A History of Art Education: Intellectual and Social Currents in Teaching the Visual Arts* (New York: Teachers College Press, 1990), 96–109. The drawing law stipulated that every city with more than 10,000 people had to provide classes in industrial and mechanical drawing for individuals over fifteen.

28. Davidson, 2, and Efland, 106.

29. Nancy Austin, "Educating American Designers for Industry, 1853-1903," in *The Cultivation of Artists in Nineteenth-Century America*, 192, 193. The Rhode Island School of Design's mission statement also provided for art lectures and exhibitions.

30. J. Frederick Hopkins, "A School Museum as an Educational Laboratory," *Pratt Institute Monthly*, April 1895, 156.

31. Walter Perry, "Art at the Columbian Exposition," *Pratt Institute Monthly*, November 1893, 118. In 1902 he summarized the recent history of art education in the United States: "Drawing was first introduced into the public schools on a purely utilitarian basis, the argument being advanced that the subject should be taught in order to train American designers, and thus prevent the importation of designers and designs from Europe. The work was exceedingly conventional, being borrowed from the English schools.... principles were taught rather than art, and very little opportunity was given for originality." ("Annual Report of the Department of Fine Arts," *Pratt Institute Monthly*, January 1902, 55).

32. Perry would soon co-author with John Spencer Clark and Mary Dana Hicks the multi-volume series, *The Teacher's Manual*, published by the Prang Company in the 1890s. These books on art instruction were widely used by public schools throughout the country. Perry would also become very active in the National Education Association, frequently lecturing at their annual meetings. His talks later provided the material for his book, *The Relation of Art to American Life*, published in 1911 (New York: Atkinson, Mentzer & Grove). He remained at Pratt for his entire career.

33. For a study on the significance of drawing in American life see *Drawn to Art: A Nineteenth-Century American Dream* by Diana Korzenik (Hanover and London: University Press of New England, 1985). Korzenik's narrative chronicles art education in Massachusetts, providing much information on Walter Smith and the Prang Company which serves as a backdrop for Pratt's initiatives.

34. *Pratt Institute, Brooklyn, N.Y.*, unpaginated.

35. *The Brooklyn Citizen*, March 11, 1890.

36. This information is contained in Charles Pratt's Founder's Day Address, October 2, 1890, reprinted in Clarke, 475. For the Spanish class see the 1892-93 *Catalogue*, 67. According to that source (70) the library training classes were also introduced because of requests from professionals in the field.

37. Editorial, *Pratt Institute Monthly*, October 2, 1892. Charles Richards began teaching at Pratt in 1888. A graduate of the Massachusetts Institute of Technology, he had previously worked at the New York College for The Training of Teachers, an outgrowth of the Industrial Education Association. He remained at Pratt through June 1898 when he left to become the Director of the Manual Training Department at Columbia Teachers College.

38. Perry to Clarke, December 15, 1891, in Clarke, 472.

39. J. Frederick Hopkins, "Report of the Department of Museums," October 23, 1893, 41–42. Reports were submitted to the Board of Trustees. Unless otherwise noted, all unpublished materials are located in the Pratt Institute Archives, Brooklyn. Numerous statements in department reports and faculty meeting minutes document details concerning Pratt's participation in the Chicago World's Fair.

40. A notice in the *Pratt Institute Monthly* (November 1893, 77–78) records visits from the President of the Finsbury Technical College in London, from Mr. Kuroda, a teacher in a Tokyo school, and guests from France, Italy, Sweden, Hawaii, the Sandwich Islands, and Austria.

41. "Art in the School Room," *The Arts*, Spring 1893, 195.

42. Perry, "Review of the Columbian Exposition," *Pratt Institute Monthly*, January 1894, 156.

43. "The Pratt Institute Exhibit at the World's Columbian Exposition," *Pratt Institute Monthly*, June 1893, 283.

44. For more on this see David Burg, *Chicago's White City of 1893* (Lexington: University of Kentucky Press, 1976), 239–249. Interesting observations about the Woman's Building are contained in Margaretta M. Lovell, "Picturing 'A City for a Single Summer': Paintings of the

World's Columbian Exposition," *Art Bulletin,* March 1996, 48–50.

45. The award was mentioned in an article in the *New York Tribune,* February 4, 1895. The Pratt women's exhibition was also praised in the *Standard Union* ("Industrial Life of Women," March 16, 1893).

46. *Pratt Institute Monthly,* October 1892, 2.

47. *School Journal,* April 15, 1893.

48. *Catalogue Pratt Institute,* 1890–1891, 11. Pratt's attitude towards women was also singled out for praise by Isaac Clarke.

49. Lily Norton, in "Business Principles for Women," noted that commercial activities do not threaten a woman's femininity. She observed, "a womanly woman is such for all time and in all places, and it will not mar her delicacy one jot or tittle that she knows which end of a check to endorse…" (*Pratt Institute Monthly,* April 1894) 261, 262.

50. A reviewer for the lecture "Self-Supporting Woman" observed: "The present attitude of society towards the wage earners…is not yet what it should be, nor what it will be before many years in this country, where it will be as much of a disgrace for our daughters to be dependent as it now is for our sons." (*Pratt Institute Monthly,* November 1892) 51. A notice in the first issue advised, "If our women readers wish to learn some of the reasons why compensation for their work is not in many cases as high as that of men for exactly similar work, let them read Hon. Carroll D. Wright's article on the subject in the July *Forum,*" (October 1892) 2. Wright later spoke at Pratt. A salary schedule, contained in a letter from Frederic Pratt to the Board of Trustees (May 9, 1896), recorded female faculty wages in the High School and the Art Department as almost half that of their male colleagues.

51. Frederic B. Pratt was officially the Secretary on the Board of Trustees, with his older brother Charles M. Pratt as President. The Board also included their brothers George and Herbert and brother-in-law Frank L. Babbott. Charles (senior) had been grooming Frederic to supervise the Institute; together they had toured European art and design schools in 1889.

52. Frederic Pratt, editorial in the *Pratt Institute Monthly,* November 1893, 79.

53. Hopkins, "The Pratt Institute," *New England Magazine,* September 1895, 103. This article provides one of the most detailed and interpretive accounts of Pratt's early history which Hopkins places within the larger context of American art education.

54. Editorial, *Pratt Institute Monthly,* October 1892, 2. Despite a continuing commitment to these principles, the department's name became the Department of Fine Arts in the fall of 1894.

55. Editorial, *Pratt Institute Monthly,* March 1894, 198.

56. Richards, "Manual Training—Where is the Root?" 191.

57. Richards, "The Functions of Drawing and Manual Training in Education," presented at the Congress on Manual and Art Education, Chicago, July 17, 1893. Reprinted in the *Pratt Institute Monthly,* November 1893, 62–65. Richards's theories are also elaborated in the *High School Brochure* (Brooklyn: Pratt Institute, 1892–93).

58. Hopkins, "The Decoration of the School-Room," *Pratt Institute Monthly,* May 1896, 251. This article was a review of the exhibition "Works of Art Suitable for the Decoration of School-Rooms" (March 21–April 10) held at the Brooklyn Institute of Arts and Sciences. Hopkins and other Pratt faculty were involved in the show's organization. The school decoration movement was begun in England by John Ruskin as a way to instill standards of "good" taste in children who would then transplant them to their home environment.

59. For Perry's views on realism see "How Can We Acquire a Better Appreciation of True Art?" in the *Pratt Institute Monthly,* December

1893, 96–102. This paper was delivered at the World's Educational Congress in Chicago, July 18, 1893.

60. Perry, "Art Education in the Schools," *Pratt Institute Monthly,* February 1893, 5.

61. Perry, "Art in Manual Training," *Pratt Institute Monthly,* March 1893, 156. Perry cited the recently constructed Brooklyn Bridge as an example of formal beauty: "Its artistic quality lies in its perfect proportions, in its unity and simplicity." As a symbol of good design (and state-of-the-art technology), the bridge appears on the Pratt Institute seal designed by Perry.

62. Perry, "How Can We Acquire a Better Appreciation of True Art?" 101.

63. Hopkins, "Report of the Department of Museums," October 31, 1894, 81.

64. H. Wayne Morgan, *New Muses: Art in American Culture 1865–1920* (Norman: University of Oklahoma Press, 1978), 40–41, and Sarah Burns, *Inventing the Modern Artist: Art and Culture in Gilded Age America* (New Haven: Yale University Press, 1996), 8–9.

65. John S. Clark, "Suggestions for the Development of the Educational Work of Pratt Institute," 2. This manuscript appears to be a rough draft of the official report dated August 15, 1893. The Prang Co. of Boston, one of the leading publishers of chromolithographs and educational art materials, had already been involved with the school while Charles Pratt was alive. In 1891, just before his death, Pratt and Prang had announced a collaborative venture in which graduates of Prang's Normal School (a correspondence course) could continue their education at Pratt. Prang offered ten annual scholarships to pupils in this program and organized travelling educational exhibits of work by Pratt and Prang students. Prang also published the journal *Modern Art* with which Arthur Wesley Dow and Ernest Fenollosa were closely involved. Prang's commitment to democratizing art through chromolithography and public school education fully accorded with the mission of Pratt.

Clark's ideas for Pratt were consistent with his philosophy of cultural idealism. He was one of the few outspoken critics of the 1894 "Report of the Committee of Ten." That document, which provided recommendations to the National Education Association on reforms for secondary education, effectively marginalized art from the high school curriculum for the next twenty-five years. Clark attacked it for neglecting "imagination and feeling" in education, and for placing "too much emphasis on facts and too little upon ideals." (See Efland, 164.)

66. Clark, 3.

67. Clark, "Report to Charles M. Pratt," August 15, 1893, 5.

68. J. F. Williams, "Report of the Technical Museum," July 1, 1889. Published information on the Museum is found in Hopkins, "Pratt Institute Museum," *Pratt Institute Monthly,* November 1892, 24–27. Detailed lists of items purchased for the Museum are contained in reports in the Pratt Archives.

69. None of these Baryes remain at the Institute, but one of the sculptures is illustrated in Hopkins' article, "Pratt Institute Museum," 25.

70. "Minutes of the Faculty Meeting," October 27, 1892, 187, 188. These meetings were attended by the chairs of each department. The adjective "technical" was subsequently dropped from the museum's title. Letters from the 1930s indicate that the remaining specimens were given away to other interested schools.

71. For more information see L. E. Palmer, "The Photograph Library," *Pratt Institute Monthly,* December 1897, 87–88. Palmer provides a vivid description: "A visitor to the Art Reference Room at the close of a busy day could have no doubt as to the usefulness of the photograph library. Sometimes it seems as if a volcanic upheaval had taken place beneath

the wide shelves, burying them in pictures of almost everything in the realm of art-creation."

72. For a detailed discussion of the photographer Käsebier and her experiences at Pratt see Barbara L. Michaels, *Gertrude Käsebier* (New York: Harry N. Abrams, Inc., 1992), 17–26.

73. Hopkins, "A School Museum as an Educational Laboratory," 157. Hopkins augmented the Pratt Museum experience with class trips to the Metropolitan Museum of Art. The first excursion took place on December 14, 1895 and was attended by sixty students and "friends outside the Institute." Hopkins reported: "Museum authorities were most courteous, their only fear being that the size of the party might cause injury to some of the smaller and more exposed casts." According to Hopkins, applications were already arriving for the second visit, despite the fact that "this trip takes one and a half hours." (Hopkins, "Report of the Department of Museums," December 21, 1895, 137.)

74. Ibid.

75. Hopkins, "Museum Suggestions," September 1892, 10. This fourteen-page report was completed for the Board of Trustees. In it Hopkins also cites the success of the reconstructed order of the Parthenon relief fragments in the Elgin Room of the British Museum. He would later duplicate the arrangement at Pratt with photographs, some of which were used to illustrate his article, "A School Museum." In this way, he wrote, the visitor sees, not a group of mutilated slabs, but "the circumstances of their position, intention and story."

76. Clarke, 516.

77. Hopkins discusses the arrangement of the room and its purpose in "Report of the Department of Museums," December 21, 1894, 91-92. Hopkins noted: "this new feature [coordinating the photos with Perry's lectures] has probably done more to bring the Museum into close contact with many students than anything which has been attempted."

78. Ernest Fenollosa, "Art Museums and Their Relation to the People," I, *The Lotos*, May 1896, 841–843. For a discussion of museums as agents for moral and cultural control of the laboring classes by the wealthy, see Alan Trachtenberg, *The Incorporation of America: Culture and Society in the Gilded Age* (New York: Hill and Wang, 1994), 140–153. Burns presents alternate views (9).

79. Hopkins, "A School Museum as an Educational Laboratory," 162. For further discussion of "progressive environmentalism," the cult of beauty, and programs of art decoration in the public schools see Kathleen Pyne, *Art and the Higher Life* (Austin: University of Texas Press, 1996), 40–41, and Boris, Chapter 5.

80. Hopkins, "Report of the Department of Museums," April 30, 1894, 62. Hopkins noted that the collection had been sold prior to the exhibition to a Mr. Thomas B. Clarke of New York.

81. Ibid.

82. Information also appeared in "Teachers-Students-and-Things," *Pratt Institute Monthly*, June 1895, 205. Hopkins delivered a lecture explaining the process which led from the initial drawing to the printed illustration. Many Pratt students trained for work in commercial illustration and the *Monthly* frequently contained reports on related issues and exhibits. An article published in February 1896 (163), for example, discussed contemporary illustrators and especially praised Abbey's Shakespeare drawings.

83. Hopkins, "Report of the Department of Museums," December 21, 1894, 91.

84. Names of lenders are found in thank-you notes written by Frederic Pratt. Hopkins acknowledged that "the success of this exhibition was largely due to the efforts of outside parties who were influential in securing loans." ("Report of the Department of Museums," June 21,

1895, 120).

85. Hopkins, "Report of the Department of Museums," September 30, 1895, 130.

86. "The Pratt Institute: A Unique Scheme of Academic, Industrial, and Art Education—Its Guiding Principle, 'To Help the Other Fellow,'" *New York Post*, December 21, 1898.

87. Hopkins wrote that the walls would be draped and the room furnished simply. He reported to Frederic Pratt that "a considerable amount of time has been taken by the planning.… Arrangements were made for the sheathing of the room, and visits were made to all the prominent New York galleries of similar size and character in order to wisely plan for the best arrangements for natural and artificial lighting." ("Report of the Department of Museums," September 30, 1895, 133 and March 22, 1896, 146.)

88. *Art Notes*, No. 2, November and December, 1896, 20. William Macbeth lived in Brooklyn and was increasingly involved with Pratt exhibitions, faculty (as clients) and the Pratt family (as customers).

89. Holmes Smith, "Modern Painting in Sweden," *Modern Art*, Fall 1896, 108-114. Articles were also published in the *Evening Post* (June 3, 1896), the *Standard-Union* (May 25, 1896), and *The Critic* (May 30, 1896). Frederic Pratt had contacted W. M. French at the Art Institute of Chicago after reading a review of the exhibition.

90. Hopkins, "Report of the Department of Museums," December 21, 1895, 132, 133.

91. Perry was initially reluctant to assume these duties. He wrote to Frederic Pratt on November 2, 1896 that if he was not given an assistant, he wished "to be relieved of the work involved in providing and taking charge of the special exhibitions."

92. The other divisions of the art department included clay-modeling, architecture, wood-carving and art-needlework. Courses in the Design Division prepared students for jobs in interior decoration and for employment designing wallpaper, textiles, carpets, and stained glass. Classes in carpentry, machine work, plumbing, and electrical construction, as well as mechanical drawing, algebra, geometry, physics, and chemistry were in the Department of Science and Technology. This information is contained in the 1894–95 catalogue.

93. The complete "Course of Study" is listed in the *Catalogue Pratt Institute*, 1892–93, 23.

94. Ibid., 22.

95. Perry, "Report of the Department of Art," June 23, 1893, 2. By the third year, students spent five mornings a week in the life class drawing from the full-length figure, and three afternoons painting from the head and, later, the figure. They also attended classes in anatomy, costume, and portraiture.

96. DuMond taught life and portrait classes at Pratt from the spring semester in 1893 until the fall of 1895. Pratt students also attended his summer school in Crécy-en-Brie in 1893 and 1894. Gertrude Käsebier accompanied them as "chaperone" as well as artist. Many notices of their activities appeared in the *Pratt Institute Monthly*. (Several of her photographs from France were included in her first exhibition at Pratt in February 1897. See "Art Studies at the Pratt," *Standard-Union*, February 1, 1897). Prellwitz was an instructor in antique, life drawing, and portraiture from 1893 until 1912. Charles Curran was employed at Pratt for only one year (1895–1896), while Guy Rose taught portraiture and drawing from the spring of 1896 through June 1898.

97. Clarke, 456.

98. James Campbell, "The Pratt Institute," *The Century Illustrated Monthly Magazine*, Vol. XLVI, May-October 1893, 870. This lengthy article, one of the most detailed descriptions of the Institute, contained

many drawings by Pratt graduate Louis Loeb. The school was congratulated for making "the work not only practical but educative," and for stimulating originality and individuality.

99. Perry, "Report of the Department of Art," June 23, 1893, pp.1-2, 6-7.

100. Pratt wrote to LaFarge on March 7, 1894 requesting his help: "Our Mr. Richards very kindly gave me your statement that you could be of assistance to me in my contemplated trip to Japan in furnishing me with a few letters to your friends." LaFarge responded immediately, as a thank-you note from Pratt on March 10 indicates.

101. For a comprehensive history, see Julia Meech and Gabriel P. Weisberg, *Japonisme Comes to America: The Japanese Impact on the Graphic Arts 1876–1925* (New York: Harry N. Abrams, Inc. in association with the Jane Voorhees Zimmerli Art Museum, Rutgers University, 1990). A more detailed account of New York circles is presented in Julia Meech-Pekarik, "Early Collectors of Japanese Prints and The Metropolitan Museum of Art," *Metropolitan Museum Journal*, Vol. 17, 1984, 93–118.

102. Pratt corresponded frequently with Professor Naibu Kanda of the Imperial University, Tokyo, and conducted business with K. M. Takahashi. Many letters are inquiries about merchandise broken or not received. In Japan he had also bought several wood-carvings by students at the Fine Arts Academy from Okakura Kakuzo, Fenollosa's Japanese protégé. He later purchased books and prints on the advice of Fenollosa and Dow. See, for example, letters from Pratt to Dow on April 10, July 18, and September 9, 1895.

103. In this capacity he supervised his own collection of paintings (sold to Dr. Charles Weld in 1886 with the understanding that it would be given to the museum upon Weld's death) and that of Sturgis Bigelow. Fenollosa was originally from Salem and had studied at Harvard and the Boston Museum of Fine Arts School. An advocate for maintaining Japanese aesthetic traditions uncontaminated by Western influences, he published articles frequently during the 1890s and served as a member of the fine arts jury at the Chicago World's Fair. In 1912 his wife arranged for posthumous publication of his two volume book, *Epochs of Chinese and Japanese Art*. For information on Fenollosa see Lawrence Chisolm, *Fenollosa: The Far East and American Culture* (New Haven: Yale University Press, 1963).

104. *Pratt Institute Monthly*, October 1893, 31–32. For illustrations of the buildings on the Wooded Island in Jackson Park and a discussion of the Japanese exhibit, see Meech and Weisberg, 31–34.

105. The event is described in "Neighborhood," *Pratt Institute Monthly*, March 1895, 154, and "Japanese Tea," *The Brooklyn Citizen*, February 27, 1895.

106. Letter from Frederic Pratt to Fenollosa, October 10, 1894. Frederic remarked, "I will deem it a great pleasure to entertain you at my house during your stay in Brooklyn."

107. A letter from Pratt to Fenollosa (March 5, 1895) mentions "a conversation which we had last fall at the house regarding work at the Institute."

108. The idea that art should be available to all economic classes was certainly not new. George Ward Nichols, for example, expressed this view in his 1877 book, *Art Education Applied to Industry* (New York: Harper & Bros., 1877), 4: "But the term 'art education' is used here in the largest sense. It means artistic and scientific instruction applied to common trades and occupations, as well as to the fine arts. It means the educated sense of the beautiful is not the special property of one class but that it may be possessed and enjoyed by all."

109. Fenollosa, quoted in "Fine Arts," *Pratt Institute Monthly*, November 1894, 62.

110. Ibid.

111. Fenollosa, "My Position in America," May 1, 1891, quoted in Kathleen Pyne, "Portrait of a Collector as an Agnostic: Charles Lang Freer and Connoisseurship," *Art Bulletin*, March 1996, 92. Fenollosa envisioned a new art inspired by Eastern spirituality. He desired to "brighten and gladden the lot of the poor…giving them leisure to cultivate taste, like the Japanese peasant." Fenollosa was also an active proponent of manual training. In July 1902 he delivered a paper at the National Educational Association on "Possibilities of Art Education in Relation to Manual Training."

112. Pratt reported to Clark that Fenollosa had "made another suggestion…that of giving a larger number of talks and possibly some teaching." Pratt also asked that similar "facts" be elicited about Dow. Denman Waldo Ross was, during these years, a friend of Fenollosa's. Dow would spend time with Ross in Italy in the summer of 1896. Ross was a trustee at the Boston Museum of Fine Arts and taught architecture at Harvard during the 1890s. He later authored *A Theory of Pure Design* (Boston: Houghton Mifflin Co., 1907) in which he failed to acknowledge Dow's contribution. For further information see Meyer, *Inspiring Reform*, 25–26.

113. Clark to Pratt, April 18, 1895. Clark attributed this to Fenollosa's extreme "enthusiasm" for Japanese art and to the fact that artists are "quite antagonistic to people who lecture" about art. Clark also informed Pratt that Fenollosa's salary was $4,000.

114. Clark to Pratt, April 16, 1895.

115. Ibid. Clark was also insulted that Fenollosa and Dow rejected the use of type forms (a Prang Company invention) in teaching. Similar objections were conveyed to Perry by Kate Foster, another Prang employee, in her letter of April 16, 1895.

116. The principal studies on Dow are Frederick C. Moffatt, *Arthur Wesley Dow (1857–1922)* (Washington, D.C.: Smithsonian Institution Press, 1977); Arthur Warren Johnson, *Arthur Wesley Dow: Historian: Artist, Teacher* (Ipswich, Massachusetts: Ipswich Historical Society, 1934); Nancy Green, *Arthur Wesley Dow and His Influence* (Ithaca, New York: Herbert F. Johnson Museum of Art, Cornell University, 1990); Dow, *Composition*, with an introduction by Joseph Maschek (Berkeley: University of California Press, 1998), *Arthur Wesley Dow (1857-1922): His Art and His Influence* (New York: Spanierman Gallery, 1999), and Nancy Green and Jessie Poesch, *Arthur Wesley Dow and American Arts & Crafts* (New York: The American Federation of Arts, 1999).

Dow's first article was "A Note on Japanese Art and What the American Artist May Learn Therefrom," *The Knight Errant*, January 1893, 114-16.

117. Clark to Pratt, April 18, 1895.

118. *Catalogue of the Artistic Property Belonging to the American Art Association, Dissolution Sale*, New York, April 25–30, 1895, 26–28. The author wrote that Rivière's prints "were designed in the manner of Japanese woodcuts, with strong outlines filled in with flat tints, no attempt being made to go into details…." Dow always maintained that he was the first Western artist to adapt Japanese woodblock techniques, although he was certainly aware of the flattened style of prints and paintings by the Pont-Aven School. Pratt's queries are knowledgeable, although rather presumptuous.

Excerpts from Fenollosa's catalogue essay were quoted in Dow, "Painting with Wooden Blocks," *Modern Art*, Summer 1896, 86–90. Dow produced several versions of each print in different color schemes. This use of non-naturalistic color, which he averred originated in his childhood experience of seeing Ipswich boats repainted in new colors each year, paralleled innovations of Gauguin and anticipated future directions of abstraction. Dow's assistant at Pratt, Hugo Froehlich, wrote that "color ought to be studied for its own sake;" it "is an expression from within, not a copying of what we see." ("The Appreciation of Art," *Pratt Institute Monthly*, May 1898, 236–238).

119. Perry to Pratt, April 25, 1895. Fenollosa must have questioned the art history lectures, because Perry also defended the historical component of the program.

120. Perry to Pratt, April 29, 1895. Fenollosa's exact demands are unknown, since his letter has not been found.

121. Perry to Pratt, August 16, 1895. Perry seems to have been very impressed with Ross, describing him as "an exceedingly interesting man." He conveys Ross's opinion that "Mr. Dow stands well with the various artists of Boston with the exception of those who believe in the old, tight and mechanical form of art."

122. Perry noted that Miss Palmer was an art teacher who had lived in Italy and had previously attended classes at Pratt.

123. He also remarked, "As a student in Mr. Dow's class, I would value it [Palmer's opinion] much more highly than that of Miss Stocking. Her letter therefore is most helpful and opportune."

124. Perry did express reservations about Dow's ability to handle the life drawing class being assigned to him. This was apparently done for financial reasons, eliminating the necessity of hiring another teacher to replace the recently departed DuMond.

125. Pratt to Fenollosa, August 22, 1895. This letter is misdated because Fenollosa's response was written on August 20. Frederic specifically remarks that these thoughts are not to be shared with Dow, but a subsequent note from Dow to Fenollosa indicates that he did read the letter.

126. Perry had just received a second letter from Palmer conveying her "great admiration for him and his work."

127. Fenollosa to Pratt, August 20, 1895. Fenollosa additionally blamed the Prang Educational Company for influencing Frederic's decision. Pratt vehemently denied this accusation in a later letter.

128. Pratt to Fenollosa, August 28, 1895. Frederic's vacillation was atypical and clearly testified to the enormity of the decision he was making. He also acknowledged the weakness of their industrial design which he described as "the most unsatisfactory of any of our classes."

129. Pratt to Fenollosa, March 31, 1896. Frederic sent him two checks and stated, "I am sorry that it has seemed best for us to sever our connections." An earlier letter from Pratt to Clark (January 3) requested "authentication" of certain facts about Fenollosa which he had learned from Perry.

130. The draft of his letter is in the collection of the Archives of American Art. The letter sent to Frederic is in the Pratt Archives. Dow anticipates here the title of William Price's Arts and Crafts periodical, *The Craftsman: The Art that is Life*.
　Despite Dow's confident assurances, he wrote Fenollosa a frantic letter five days later (September 17, 1895) asking for general guidelines. He worried that "at Pratt I [will] meet entirely new conditions requiring probably radical changes in my present mode of teaching."

131. Dow, "Notes Delivered before 1895 at a Private Boston School," Archives of American Art, 1. For additional passages from this talk see Chisolm, 185–186.

132. Dow, "Lecture for the Boston Students' Association," February 1894, quoted in Johnson, 61. For Dow and Perry, idealism also led to conservative opinions. In a critique of public school art education Perry wrote: "…students are allowed to draw anything; the ability to draw an ashbarrel is often considered of more importance than the appreciation of a beautiful Greek ornament…or the harmony of line and color in a…conventional ornament." ("Art Education in the Schools," *Pratt Institute Monthly*, February 1893, 128). Dow, in a similar vein, inveighed, "They [students] are misled to believe that a representation of anything is art; and this idea results in…realistic paintings and sculptures, photographic portraits, vulgar nudities, pictures of blood and horror, the ugliness and confusion of farm yards, sloppy still-life and flowers, or silly portrayals of children or animals." ("The Place of Composition in

Art Education," *Pratt Institute Monthly*, February 1896, 161.)

133. Dow, *Composition: A Series of Exercises in Art Structure for the Use of Students and Teachers* (Garden City, New York: Doubleday, Page & Co., 1913), 3–4. The first edition was published by J. Bowles (Boston) in 1899 under the title *Composition: A Series of Exercises Selected from a New System of Art Education*.
　A similar bias against imitation, which was seen as antithetical to creativity, was expressed by Perry, Hopkins, and Richards. Their criticism was directed at a realist style in painting as well as South Kensington design training.

134. Dow's account of his Parisian study is quoted in Frederick W. Coburn, "Arthur W. Dow and His Work as a Teacher," *Art Education*, 1901, 12–17.

135. Ibid., 12. He recalled: "Japanese prints, the cheap kind that one buys at the Bon Marché, were in great demand. We hoped to wrest from them the secret of being decorative."

136. Dow, "Modernism in Art," read at the 1916 annual meeting of the College Art Association of America. Quoted in Chisolm, 239. These ideas were introduced in Dow's first article, "A Note on Japanese Art and on What the American Artist May Learn Therefrom": "In the academic and realistic schools scant attention is paid to composition, though it is the very life-blood of art. The energies are focussed upon a laborious method of learning to draw, with accurate representation as the chief object…. It is not surprising that many who draw well are sadly lacking in the ability to make an artistic use of their skill." (114) He later recollected that in Paris "it was impossible to get from the instructors any definite principles, any guiding thoughts as to composition." ("The Place of Composition in Art Education," 160).

137. Dow, *Composition*, 1913, 3.

138. Dow, "Appreciation," *Pratt Institute Monthly*, January 1899, 60-62. He cited the compositions of Albert Besnard and Edgar Degas as "the very essence of art itself".

139. Max Weber, "The Filling of Space," *Platinum Print*, Volume 1, December 1913, 6.

140. Dow, "A Note on Japanese Art," 114.

141. Max Weber has left the most detailed account of Dow's teaching practices. Weber recalled that "he brought prints by Utamaro, Hiroshige, Hokusai, and Korin into his class, and fine reproductions of the works of masters of the Renaissance. To the advanced classes he gave talks on the history of art and showed them lantern slides—paintings and architecture of the Renaissance, the Italian primitives, Gothic architecture and sculpture…." (Holger Cahill, *Max Weber* [New York: The Downtown Gallery, 1930], 5).
　Fenollosa, following the example of John LaFarge, had paired Japanese and Italian artists in his catalogue essay for Dow's 1895 Boston Museum of Fine Arts exhibition. He wrote that "the Japanese print-designer stands side by side with the Florentine worker in fresco, and with all modern French masters who have broken away from academic traditions." (Fenollosa, *Special Exhibition of Color Prints Designed, Engraved and Printed by Arthur W. Dow* [Boston: Museum of Fine Arts, April 18-June 1, 1895], 4).

142. Cahill, 6. Puvis de Chavannes was admired by both Dow and Fenollosa, who discussed his work in *Mural Painting in the Boston Public Library* (Boston: Curtis and Cameron, 1896). An exhibit of Copley reproductive prints of the murals, published by Curtis and Cameron, was held at the Pratt Gallery in January 1896.

143. Dow faulted Leonardo da Vinci for this development. For his discussions see, especially, *Composition*, 1913, 4; "The Responsibility of the Artist as Educator," *The Lotos*, February 1896, 609–12, and "The Place of Composition in Art Education," 161. Dow preferred a flat planar style of painting because he saw it as closer to the decorative tradition.

He believed that after the Renaissance, when the artist and designer parted company, "painting, which is essentially a rhythmic harmony of colored spaces, became sculptural, an imitation of modeling."

144. Fenollosa expressed this view in his article "Art Museums and their Relation to the People" (482): "There has been a tendency in some professional quarters to value art narrowly for art's sake, to claim the privilege for artists of a close community, to deny the ability of the public to think, or write or criticize, or take serious concern about matters of art. For these specialists art is technique; studio tradition is sacred…."

145. Dow, "The Responsibility of the Artist as an Educator," 611. Dow also elaborated these ideas in "Appreciation," *Pratt Institute Monthly*, January 1899, 60–62.

146. Dow, "The Responsibility of the Artist as an Educator," 611. Joseph Maschek, "Dow's 'Way' to Modernity for Everybody," in Dow, *Composition*, ed. Maschek, 3.

147. Dow, "The Place of Composition in Art Education," 162.

148. Dow, "Some Results of a Synthetic Method of Art Instruction," *Pratt Institute Monthly*, December 1897, 69.

149. Dow, "A Note on a New System of Art-Teaching," *Pratt Institute Monthly*, December 1896, 92. Dow described the straight lines as "simple exercises of the mind…pure abstractions, having no reference to use, and not being representations of anything."

150. Weber recounted this exercise in detail: "He would come into class and make an unbounded drawing of trees and hills, or perhaps a winding road against the sky. Then he would ask the class to copy the drawing freely and to enclose it in a rectangle, to make a horizontal picture or a vertical, as they chose, and to make whatever changes necessary to fit the drawing to the frame which they had selected, to balance the drawing by making less foreground, or more sky, to change the masses, and what not. He would then criticize the studies, emphasizing good design." (Cahill, *Max Weber*, 5.)

151. Dow, as well as Perry, valued these fabrics highly. They were purchased by the Pratts in 1897 on the advice of Dow, Perry and Denman Ross (a textiles connoisseur) from a Florentine collector named Salvadore. Representing diverse cultures and periods from Coptic Egypt to nineteenth century France, they were exhibited five times in the gallery and many were donated to the Institute for instructional purposes. In Dow's article "The Pratt Collection of Textile Fabrics," published in the *Pratt Institute Monthly* (March 1900, 97–101), he discussed their importance for teaching color, the "music of line," and social history, referring to them as "cryptograms" gathered from "the wreckage of past civilizations." Dow noted that while casts and photographs were useful for conveying the beauty of form, fabrics and Japanese prints were essential to understanding color. His interest in textiles paralleled studies of the decorative arts in Germany by Alois Riegl and members of the *Jugendstil* movement which would be influential to the development of abstraction in painting.

152. "Fine Arts," *Pratt Institute Monthly*, October 1895, 52. Although these notices were published unsigned, Perry wrote the statements for the Department of Art.

153. "Among the Departments: Fine Arts," *Pratt Institute Monthly*, January 1895, 103.

154. Hugo Froehlich later co-authored *Textbooks of Art Education* for the Prang Educational Co. and lectured at Chataqua Institute.

155. Perry, "Report of the Department of Art," June 19, 1896, 10. Perry observed that initially some students were lost, but that an increase was ultimately expected. He added that the work in the annual exhibit revealed greater individuality in the life and portrait drawings (taught by Guy Rose) than ever before.

A typical response to Dow's novel techniques was published in the "High School" notices in the *Pratt Institute Monthly* (March 1896, 209). Jessie Morse wrote: "The girls were at first inclined to laugh at the simplicity of Mr. A. W. Dow's squares and spaces, but already before this writing have found this phase of art a dignified and serious matter."

Further publicity for Dow appeared in an article in *The Brooklyn Eagle* titled "Evidence of Success in the Various Departments" (May 31, 1896). The author described Dow's approach, stating that, "he makes technical skill play an incidental part in the thought of the work itself." "His constant endeavor is to have them [the student] find the thought back of the work itself and to lead them out of the mechanical ruts which so often lead to failure in the end."

156. [Fenollosa] "Arthur W. Dow," *The Lotos*, March 1896, 709–10. He wrote that within a few weeks after Dow's arrival, "the power of the new method over the latent faculty of creation in young students was amply demonstrated."

157. Dow, "Composition," *Catalogue, Pratt Institute*, 1896–97, 50–51.

158. Perry, "Report of the Department of Art," October 31, 1898, 7–8. In 1902 Navajo Indians posed for the class.

159. Perry, "Report of the Department of Art," June 23, 1899, 12.

160. Ibid., 10.

161. Perry, "The Significance of the Work of the Department of Fine Arts," *Pratt Institute Monthly*, January, 1901, 53-55. Perry responded to criticism regarding the "scattered" nature of Pratt classes, replying that "there never were 'many things,' but rather many ways of doing one thing well, and that one thing was something possessing or leading to the beautiful, something that would awaken within the student the creative faculty, that would lead to the expression of new and original ideas…."

162. Beck asserted that "when the student has become sensitive to beautiful proportions of spacing, of light and dark, and good arrangements of color, he is not so easily confused when confronted with the apparently capricious arrangements of the same elements that occur in pictures in which figures are made to 'tell a story.'" ("Annual Report of the Department of Fine Arts," *Pratt Institute Monthly*, January 1902, 52–53). Many of Dow's students prepared for careers in illustration.

163. Ibid., 60.

164. See Chisolm, 192–194 and Moffatt, 91. Dow's Pratt student Mary Covel introduced his work to the Art Institute of Chicago. Pupils in the Normal School were usually experienced teachers with previous training who enrolled at Pratt to receive degrees enabling them to become supervisors within art departments. In 1903 only one in three applicants was accepted. Of the forty-one incoming students, twenty-three had resigned from prior teaching jobs. Many had studied at the Art Student's League, Cooper Union, the Rhode Island School of Design, the Massachusetts Normal Art School, Drexel Institute, Stanford University, Teachers' College and the Chicago Art Institute. (Perry, "Annual Report of the Department of Fine Arts," *Pratt Institute Monthly*, December 1903, 52).

165. See Clark. Hicks, and Perry, *Teacher's Manual*, Part IV, Books 7 and 8, Sixth Year (Boston: The Prang Educational Company, 1899), 45–50 and 171–172. Several of the artists shown at the Pratt Gallery, including John LaFarge and Edwin Howland Blashfield, were also featured in this book.

166. See, for example, Mable Key, "A New System of Art Education," *Brush and Pencil*, August 1899, 258–270 (she was a student at the school of the Art Institute of Chicago); Frederick W. Coburn, "Arthur W. Dow and his Work as a Teacher," *Art Education*, 1901, 12–17 (also illustrated with work by Pratt students); "Composition in Drawing," *New York Sun*, May 28, 1899 (this included many illustrations from his book); and Wilhelmena Seegmiller, "Art Education in the Public Schools," *Pratt Institute Monthly*, January 1899, 69–70. Seegmiller

supervised art instruction in the Indianapolis public school system. Dow's influence in the Midwest was furthered by his lecture series in Chicago and Minnesota during the spring of 1900.

167. "Pratt Institute Notes," *New York Herald*, March 26, 1899.

168. Herbert Read, *Education Through Art* (New York: Pantheon, 1958), 207–208.

169. "Work of Pratt Institute," *Art Interchange*, February 1902, 29.

170. Perry, "Report of the Department of Art," March 22, 1890, 2–5. Coburn's statements are quoted from this source. He faulted the League for their exclusive reliance on drawing "the nude figure," observing that "in spite of four or five years of grind at the antique and life, the league man and woman was not properly prepared for a profession. The educational theory of the thing was wrong.... No account was made of what the psychologists call the fatigue point."

171. Perry, "Report of the Department of Art," June 13, 1897, 15. He wrote: "Beginning in October 1896, a plan was perfected for the holding of regular exhibitions...to succeed each other in intervals of three or four weeks."

172. For a study of this society and nineteenth-century Brooklyn art life see Clark S. Marlor, *A History of the Brooklyn Art Association with an Index of Exhibitions* (New York: James F. Carr, 1970), and Linda Ferber, *Brooklyn Before the Bridge: American Paintings from The Long Island Historical Society* (Brooklyn: The Brooklyn Museum, 1982).

173. Norton, "Exhibition of Paintings by Robert Reid," *Pratt Institute Monthly*, January 1897, 153.

174. Perry, "Report of the Art Department," September 25, 1899, 10. He noted that Grueby Pottery sold $300 worth of merchandise. He also mentioned that new publishers had been found—Heintzemann Press of Boston—to print the circulars, "prov[ing] that inexpensive printing does not necessarily imply inartistic work." The brochure for the Tiffany exhibition, one of the most lavish produced, had been printed by De Vinne Press.

175. Minutes for a faculty meeting on November 23, 1896 record Perry's request for suggestions as well as opinions about the current Reid show. Mary Plummer, the Director of the Library, reported that her staff found the display "of the works of one artist...especially interesting and valuable." William McAndrew, the principal of the High School, provided names of several Brooklyn collectors who might be willing to lend paintings.

176. It is unclear whether Perry's letters were lost or never saved in the first place. Some of his correspondence remains in the school archives, but little of it relates to the gallery.

177. Prellwitz wrote an article for the *Pratt Institute Monthly* on Cornish, and Rose contributed a report on Americans at Giverny.

178. Bennard Perlman wrote: "it was through Davies that an arrangement was made for a Henri exhibit there [Pratt], too, at the end of the year." (Perlman, *Robert Henri: His Life and Art* [New York: Dover Press, 1991], 48). According to Richard Love, "we must assume that Butler's contact at Pratt was Prellwitz...owing to their close friendship." (Love, *Theodore Earl Butler: Emergence from Monet's Shadow* [Chicago: Haase-Mumm Publishing Co., 1985], 205).

179. Perry to William Macbeth, June 17, 1896. The letter is in the collection of the Archives of American Art. Hopkins also wrote to Macbeth in 1896 about paintings for which he had provided frames. The correspondence between Macbeth and the various members of the Pratt family is voluminous and covers the years between 1893 and the 1930s. Many of the paintings given by George Pratt to Amherst College involved purchases from the Macbeth Gallery.

180. See, among others, letters from Perry to Macbeth dated October 14,

1897, February 28, 1899 and June 20, 1901. A letter from Perry to Macbeth (October 2, 1897) notes that Macbeth had first mentioned the idea of a Davies exhibition in the spring of 1896.

181. Perry, "Report of the Art Department," December 22, 1899, unpaginated, and June 21, 1900, 20.

182. "Landscape Paintings by Charles H. Davis at Pratt Institute, Brooklyn," *The Artist*, January 1900, lxxxi, and "Pratt," *New York Tribune*, November 12, 1898.

183. Perry, "Report of the Art Department," June 21, 1900, 19.

184. The text was reprinted in Norton, "Exhibition in Pratt Institute Art Gallery," *Pratt Institute Monthly*, November 1899, 22. Mention was also made of the influence of "Chinese and Japanese crackles." Statements in the circulars were always unsigned.

185. "Lithographs: Louis Prang Tells Pratt Students How They Are Made," *Brooklyn Daily Times*, January 6, 1897.

186. This letter from LaFarge to Perry was printed on the back of the circular for LaFarge's show at Pratt (October 14-November 19, 1898). Other passages in it were evidently copied from earlier writings because they appeared in correspondence from February 25, 1895, published in the catalogue of his Durand-Ruel exhibition. See *John LaFarge: Paintings, Studies, Sketches, and Drawings. Monthly Records of Travel, 1886 and 1890–91*, 31, Cat. no. 98 (New York: Durand-Ruel Gallery, 1895).

LaFarge remained interested in Pratt, visiting and praising the annual student exhibition in 1901. (See Coburn, "Arthur W. Dow and His Work as a Teacher," 16.)

187. Norton, "Notes from the Departments: Displays in the Pratt Institute Exhibition Gallery," *Pratt Institute Monthly*, June 1899, 218.

188. Norton, "Work by Mr. Robert Blum in the Art Gallery of Pratt Institute," *Pratt Institute Monthly*, February 1900, 95.

189. Norton, "The Exhibition Gallery," *Pratt Institute Monthly*, January 1901, 71.

190. See H. Barbara Weinberg, "Robert Reid: Academic 'Impressionist,'" *Archives of American Art Journal*, 15: 1, 1975, 10. The "privilege" of seeing these drawings was certainly enhanced by their fame and topicality. Articles and books which discussed and illustrated murals represented in Pratt exhibitions included, among others, Royal Cortissoz, "The Making of a Mural Decoration," *Scribner's Magazine*, January 1896, 58–63; Cortissoz, "A Decorative Painting by Robert Blum," *Scribner's Magazine*, January 1896, 3-9; and Pauline King, *American Mural Painting* (Boston: Noyes, Platt & Co., 1901).

191. Perry, "Report of the Art Department," June 21, 1900, 19.

192. See "Pratt Institute," *The Brooklyn Citizen*, February 11, 1900 and "Pratt Institute," *The Brooklyn Eagle*, February 12, 1900. The *Eagle* reporter remarked: "The paintings [by Butler] are interesting as representing the work of an extreme Impressionist and are in strong contrast to the more conservative methods of work shown in the paintings of Charles E. Davis, which were on exhibition in the gallery during December."

193. Perry, "Art Exhibitions," *Pratt Institute Monthly*, January 1902, 78. He wrote: "A greater contrast in spirit and aim can hardly be found than that between these paintings and the exhibition immediately preceding it.... With Mr. Davies nature is not the object, but a treasure-house from which he clothes with beauty the conceptions of a poetic and original temperament. M. Moret, on the contrary, so rejoices in nature as it exists, that he aims at the expression of it in complete fullness; trusting his own marvelous skill in representation." Similar comments appeared in the *Student Bulletin* entry for December 6, 1901.

194. Circular for "Exhibition of Landscapes and Portraits by Robert Henri," at Pratt Institute, December 18, 1902–January 31, 1903; and circular for "Charles H. Davis," December 4–30, 1899, reprinted in Norton, "The Exhibition Gallery," *Pratt Institute Monthly*, January 1900, 50. This statement also emphasized Davis' rejection of the academic French style, noting that he found the atmosphere of the Parisian studios "oppressive." Perry had admired Davis' work for several years. In a letter to Frederic Pratt, August 24, 1895, he mentioned seeing three of Davis' landscapes.

195. Norton, "Displays in the Pratt Institute Exhibition Gallery," *Pratt Institute Monthly*, June 1899, 219.

196. *Art Notes*, 5, November 1897, 8.

197. Davies was praised in the Fenollosa-dominated journal *The Lotos* (February 1896, 627). See Chisolm, 124. Käsebier is quoted in Michaels, 118.

198. Perry, "Art Exhibitions," *Pratt Institute Monthly*, January 1902, 77, and the circular for "Arthur B. Davies," November 4–30, 1901.

199. Dow, "Mrs. Gertrude Käsebier's Portrait Photographs," *Camera Notes*, July 1899, 22.

200. *Student Bulletin*, January 22, 1904. These articles were untitled, unsigned, and the magazine was unpaginated. Following the demise of the *Pratt Institute Monthly* at the end of 1903, however, this was the only school publication. In 1904 classes in photography were still not offered at Pratt.

201. Bruce Weber, "Robert Frederick Blum (1857–1903) and His Milieu" (Ph.D. dissertation, City University of New York, 1985), 389 and 398. Weber suggests that Dow arranged Blum's Pratt show. See also *Robert F. Blum 1857–1903* (Cincinnati: The Cincinnati Art Museum, 1966), 6.

202. "The Art World," *Commercial Advertiser*, January 10, 1900.

203. "In the Art World," *Commercial Advertiser*, January 18, 1898.

204. [Perry], "Pratt Institute," *Brooklyn Daily Times*, January 15, 1898. Both the circular and the *Brooklyn Daily Times* article cite the Pratt exhibition as being the first to show Davies' drawings. They note the two earlier exhibits of his paintings at the Macbeth Gallery in 1896 and 1897. As mentioned above, William Macbeth organized the Pratt show and soon after held another at his gallery which included many drawings. See Bennard B. Perlman, *The Lives, Loves, and Art of Arthur B. Davies* (Albany: State University of New York Press, 1998), 101. Perlman seems to have been unaware of this first Pratt exhibition, while Joseph Czestochowski dates it incorrectly as 1897, (*The Works of Arthur B. Davies* [Chicago: University of Chicago Press, 1979], xviii).

205. "Mr. T. E. Butler's Pictures: An Impressionist's Exhibition at the Pratt Institute Gallery That is Instructive," *The Brooklyn Eagle*, February 7, 1900.

206. Norton, "The Paintings of Theodore E. Butler in the Art Gallery of Pratt Institute, and Certain Phases of Art," *Pratt Institute Monthly*, March 1900, 118-119. For a discussion of critical responses to Butler's art, especially at the Durand-Ruel Gallery a month later, see Love, 207–210.

207. "The Art World," *Commercial Advertiser*, April 22, 1899. The writer continued: "Mr. Dow has stopped just where he should have gone well on to a finish. For pictorial purposes he seems not to have said enough."

208. Norton, "Displays in the Pratt Institute Exhibition Gallery," *Pratt Institute Monthly*, June 1899, 218.

209. See "Pratt Trustees Explain Plan to End High School," *The Brooklyn Eagle*, May 5, 1904. This article reported that the trustees felt "that the original purpose of the founder has been accomplished,"

because manual training has finally been incorporated into the public school system. They also were reluctant to invest in the new technology necessary to keep Pratt's High School competitive with the public school.

210. Perry, "Annual Report of the Department of Fine Arts," *Pratt Institute Monthly*, January 1902, 61–65 ("The Arts and Crafts").

211. Perry. "Annual Report of the Department of Fine Arts," *Pratt Institute Monthly*, January 1903, 60 and 65.

212. Perry, "Annual Report," January 1902, 61. "The Arts and Crafts" section of the Report began with an "inspirational" quote from William Morris: "It is a thing to be deprecated that there should be a class of mere artists who furnish designs ready-made to what you may call the technical designers. I think it is desirable that the artist and what is technically called the designer should be practically one." The same opinion was elaborated by Denman Ross in "The Arts and Crafts: A Diagnosis," *Handicraft*, January 1903, 229–243.

213 Pratt to Perry, December 16, 1902.

214. Pratt to Perry, January 30, 1903.

215. Coburn, 16.

216. Details of their relationship are described in Latimer, "A Field of Influence," 226–227. Several articles appeared in the press on connections between the two schools.

217. Pratt to Dow, January 19, 1903. This information about the "field-work" visits was contained in Pratt's letter to Perry from January 30.

218. Pratt to Perry, June 29, 1903, 7-8.

219. Sylvester Baxter, "Handicraft, and its Extension, at Ipswich," *Handicraft*, February 1903, 253. Several pages are devoted to a discussion of this approach, whose goal is to put the artist "en rapport with the primitive state of mind and the primitive view of things." Baxter traces the influence of Frank Hamilton Cushing's ideas on Dow.

220. Dow to Pratt, December 6, 1903. His official resignation was sent to the Board of Trustees on December 5. Dow praised Pratt publicly in the introduction to his 1913 edition of *Composition:* "The results of the work thus begun [Dow's activities in Boston] attracted the attention of some educators, notably Mr. Frederic B. Pratt, of that great institution where a father's vision has been given form by the sons. Through his personal interest and confidence in these structural principles, a larger opportunity was offered in the art department of Pratt Institute, Brooklyn." (5)

221. Pratt to Dow, January 11, 1904. Because of problems with the mail, Dow evidently did not receive this letter for many months, leading to misunderstandings and concern on his part. Frederic wrote him again (May 18) with the following reassurances: "I wrote you immediately upon the receipt of your letter, but presume my reply is following you up after the fashion of foreign mail…. You and Mr. Rochards [sic] were quite right about me for,—though I was very, very sorry to have you go,—I never questioned for a moment the absolute fairness of your decision, and I am sorry that my apparent silence and a bit of idle gossip should have disturbed you."

222. Perry, "Annual Report of the Department of Fine Arts," *Pratt Institute Monthly*, December 1903, 65.

223. See Henry T. Bailey, *The Flush of the Dawn: Notes on Art Education* (New York: Davis Press, 1910). Efland (179–181) cites Bailey and discusses this new direction. He references the 1906 Massachusetts Board of Education report on industrial and technical education which criticized manual training, and notes that manufacturers came to "demand…a more relevant form of industrial education" distinct from the crafts tradition and from designers trained in the fine arts.

Pratt Gallery Exhibitions

The Gallery in Main Building

April 1894: Greek Glass

May 1894: Drawings loaned from Charles Scribner's

October–December 1894: Japanese objects (textiles, ceramics, wood-carvings and bronzes) from the collection of Frederic Pratt

March 1895: Posters (Beardsley, Grasset, Mucha, Steinlen, Read, Schwabe, Cheret, Toulouse-Lautrec, Bradley, Penfield, Cox, Hall)

Spring [May] 1895: Drawings loaned from Scribner's, Century, Harper's, Life, and Truth (Gibson, Blum, Frost, Hassam, Cox, Smith, Abbey, DuMond, Smedley, Pennell, Birch and others)

September–October 1895: Color woodcuts by Arthur Wesley Dow (previously shown in the Japanese Corridor of the Boston Museum of Fine Arts)

January–February 15 1896: 143 photographs of the Boston Public Library loaned by Curtis & Cameron (50 handbooks of the Library were sold in conjunction with the exhibition)

April 1896: Landscape paintings by Dow

January–May 1899: Photographs of Sioux Indians from Buffalo Bill's Wild West by Gertrude Käsebier given to Pratt

The Gallery in the Library

May–June 1896: "Representative Works of Contemporary Swedish Artists" (includes Anders Zorn, Carl Larsson, Karl Nordstrom, Nils Kreuger, Oscar Björk, Baron Gustaf Cederstörm, Per Eckström and others)

October 1896: Old Master drawings

November 2–13, 1896: Platinotype reproductions of paintings by Edward Burne-Jones, Dante Gabriel Rossetti, and George Frederick Watts.

November 19–December 5, 1896: "Robert Reid" (20 paintings, 3 pastels and 20 drawings including sketches for panels in the Congressional Library in Washington and the dome of the Manufacturers and Liberal Arts Building at the Columbian Exposition)

January 1897: "Oriental Ceramic Art" (116 lithographs by Louis Prang & Co. of the W. T. Walters Collection)

February 1–13, 1897: "Art Studies in Photography" by Gertrude Käsebier (150 portrait studies)

March 1–27, 1897: "An Exhibition…loaned by the Tiffany Glass and Decorating Company illustrating Handicraft in its application to work in Glass: Windows, Mosaics, Vases, Plaques and Lamps"

April 1897: Reproductions of Old Masters by the Berlin Photogravure Co. (Rembrandt, Van Dyck, Rubens, Murillo, Velasquez, Raphael, Da Vinci and others)

May 1–14, 1897: Photogravures of 70 paintings by Jean-Louis-Ernest Meissonier

May 20–June 12, 1897: "The Copley Prints" (Reproductions by Curtis & Cameron of mural decorations in the Boston Public Library, the Library of Congress, the Walker Art Building at Bowdoin College, and paintings from the Boston Museum of Fine Arts)

October 14–November 6, 1897: Book Covers and Designs (loaned by Appleton, Century, Harper's, Houghton Mifflin, Lippincott, MacMillan, Putnam's, Scribner's, and others)

November 15–December 1, 1897: "Textiles" (European and Asian; gift of Mrs. Charles Pratt to the Institute)

December 6, 1897–January 8, 1898: "Art Ecclesiastical and Memorial" loaned by J. & R. Lamb, "illustrating Art Handicraft in its most recent development in Glass, Metal, Mosaic, Stone, Marble and Textiles"

January 12–29, 1898: "An Exhibition of Paintings and Pastel Drawings by Arthur B. Davies"

February 7–26, 1898: "Art in Metal" (wrought-iron work, castings in brass and bronze from John Williams; wrought-iron from Eugene Kulinski & Co.; bronze and brass castings from Edward F. Caldwell & Co.; Japanese bronzes from Frederic Pratt)

March 7–31, 1898: "Textiles" (second installment —14th and 15th century, many Sicilian, Arabian, and Spanish examples)

April 6–13, 1898: "Exhibition of Japanese Color Prints: Landscapes by Hiroshige" lent by Dow (includes many prints from the series 53 *Stations of the Tokaido*)

June 1898: Watercolors by Anna Fischer

October 14–November 5, 1898 (extended to November 17): "John LaFarge" (200 pencil

drawings, 51 color sketches for stained glass windows, and 75 watercolor studies)

November 25–December 31, 1898: "The Chapman Collection: Paintings from Spanish, Italian, French, Flemish, Dutch, German and English Schools" lent by Henry T. Chapman (29 paintings by Dürer, Bronzino, Fragonard, Rosa, Carraci, Cuyp, and others)

January 5–31, 1899: "Doll Collection" lent by Annie Fields (60 international and American folk dolls) and "Textiles" (third installment)

February 6–March 4, 1899: "Henry and Edith Mitchell Prellwitz" (40 paintings)

March 7–21, 1899: "Drawings by the Old Masters" lent anonymously (works by Raphael, Michelangelo, Leonardo da Vinci, Titian, Rembrandt, Van Dyck, Rubens and others; organized by the Macbeth Gallery)

March 21–April 1, 1899: "Antique Oriental Rugs" lent by Joseph Wild & Co. and others (rugs from Persia, India, Turkey and China)

April 11–May 6, 1899: "Arthur W. Dow" (paintings, drawings and color prints)

October 2–31, 1899: "Grueby Pottery and Antique Textiles"

November 1–30, 1899: "Butterflies and Moths" lent by the Denton Brothers of Wellesley, Massachusetts (collection of 500 specimens)

November 20–December 2, 1899: "Ernest Haskell" (paintings, etchings, monotypes and drawings)

December 4–30, 1899: "Charles H. Davis" (36 paintings)

January 9–27, 1900: "Robert F. Blum: Exhibition of Sketches, Studies and Drawings, relating to the Production of Mural Decoration, together with Japanese Subjects in Water-color" (the murals included *The Vintage Festival, Moods of Music,* and *Allegretto*)

February 5–26, 1900: "Theodore E. Butler" (32 paintings)

March 5–31, 1900: "Japanese Prints and Books" lent by Dow (Hokusai, Moronobu, Okumura, Masanobu, Harunobu, Koriusai, Yeizan, Yeisen, Kunisada, Hiroshige and Kionaga; the exhibition also contained printing tools)

April 4–28, 1900: "Iridescent Glass, Brocades and Rare Oriental Rugs" lent by Daniel Z. Noorian

May 1–31, 1900: "Rookwood Pottery" (68 objects)

October 10–31, 1900: "Volkmar Pottery"

November 5–30, 1900: "Edwin Howland Blashfield: Exhibition of Sketches, Color Studies, and Drawings"

December 4–29, 1900: "Willard D Paddock: Exhibition of Portrait Drawings, Composition Sketches and Paintings"

January 4–31, 1901: "Joseph Lindon: Color Studies from Ancient and Medieval Works of Art" (56 sketches of Egyptian, Greek and Italian sculptures, architectural motifs and frescoes)

February 4–28, 1901: "Antique Oriental Rugs, Embroideries and Metal Works" lent by John T. Kerersey and Co., Charles M. Pratt, and Frederic Pratt

March 1901: Indian baskets and blankets from the collections of Frank M. Covert and Frederic Pratt, shown together with baskets made by faculty members. The objects were primarily from Western and Northern tribes including Apaches, Pimas, Mokis, and the Alaskan and Aleutian-Island Indians

April 1901: "Antique Textiles" (Institute collection)

May 1901: "History of Bookmaking" (organized by the Library Department; illustrated the history of the book from Egyptian and Assyrian periods to the present)

May 13–31, 1901: "Butterflies and Moths" (Denton Collection)

May 24–June 9, 1901: "Exhibitions by Mr. and Mrs. Guy Rose" (in the Department of Domestic Arts)

June 1901: Reproductions by the Berlin Photographic Company of masterpieces from the National Gallery of London and the Berlin Gallery

November 4–30, 1901: "Arthur B. Davies: Paintings and Drawings" (26 paintings and 90 notes and sketches)

December 3–14, 1901: "Henri Moret" (20 paintings loaned by Durand-Ruel of New York)

December 1901: "The Copley Prints" illustrating American mural decoration

January 13–February 1902: "Exhibition of Drawings, Sketches and Color Studies illustrating Interior Decoration by Mr. E. Prentice Treadwell"

February 5–19, 1902: "The Rowan Collection of Flower Paintings" (500 watercolors of the flora of Australia, New Zealand, the Caribbean and the United States)

February 24–March 8, 1902: "Original Photographs of Figures and Landscapes by Mr. Clarence H. White"

March 19–April 5, 1902: "Pictures Made in Japan by Joseph Lindon Smith"

April 1902: "William Wendt" (25 landscapes)

October 1902: Sculptures by Hermon A. Macneil (22 sculptures of Native Americans)

October 28–November 8, 1902: "Original Drawings by Masters of the Fifteenth, Sixteenth, and Seventeenth Centuries" from the Nahl Collection of Old Masters, loaned by William C. Paul

November 14–December 13, 1902: "Henry B. Snell" (31 watercolor landscapes and marines)

December 18–January 31, 1903: "Exhibition of Landscapes and Portraits by Robert Henri" (42 paintings)

February 4–26, 1903: "Original Drawings and Paintings for Illustration" (loaned by Charles Scribner's Sons; included Glackens, Pyle, Shinn and others)

March 2–14, 1903: "Paintings by Claude Jean Monet" (loaned by Durand-Ruel of New York)

March 17–April 4, 1903: "Photographic Reproductions in Tone and Color of the Works of Arnold Böcklin"

April 7–19, 1903: "Exhibition of the Pratt Institute Collection of Antique Italian and Oriental Textiles" shown together with Native American baskets loaned by Frank M. Covert

May–June 1903: "Book Decoration" (book-plates and book-binding; organized by the Library Department)

October 16–31, 1903: "Paintings by Van Perrine"

November 1903: Photographic reproductions by Hanfstaengel of Holbein drawings

December 3–31, 1903: "Paintings and Drawings by Frank Vincent DuMond"

Highlights of Exhibitions 1904–1912

January 1904: Photographs by Clarence White

March 2–26, 1904: "Exhibitions of Paintings by Charles C. Curran" (31 paintings)

May 4–21, 1904: "Photographs of Alvin Langdon Coburn"

January 12–February 3, 1906: "Exhibition by the Tiffany Glass and Decorating Company"

March 13–31, 1906: "Drawings by Kenyon Cox" (nearly 100 drawings, color sketches and several photographs of finished murals)

April 24–May 5, 1906: "Etchings by Joseph Pennell"

October 19–November 10, 1906: "Photographs of American Indians and Indian Life by Edward S. Curtis"

April 1908: "Paintings and Photographs in Monotone and Color by Edward J. Steichen" (36 paintings, 30 plates and 25 monotones)

October 19–November 7, 1908: "Fifty Paintings and Illustrations by Mr. Howard Pyle"

January 17–29, 1910: "Exhibition of Modern French Paintings" loaned by Durand-Ruel of New York (Manet, Degas, Pissarro, Boudin, Renoir, Cassatt, Maufra)

February 1–19, 1910: "Fifty Paintings by William M. Chase"

March 1910: "Etchings by Giambattista Piranesi"

April 18–30, 1910: "Thirty-Five Paintings by Emil Carlsen"

November 8–30, 1912: "Exhibition of Twenty-four Landscape Paintings by Birge Harrison"

Exhibition Checklist

All photographs, except Pratt archival materials, are by Dorothy Zeidmann unless otherwise noted.

Edwin Austin Abbey
Fair Margaret in Her Torn Kirtel Led the Lorn Traveller up the Path, from *The Vicar of Wakefield.* 1886
Ink on paper, 7 x 11 5/8"
Collection of Walt Reed

Edwin Austin Abbey
Study for Wrestling Scene from *As You Like It.* n. d.
Pen and ink on paper, 21 x 13 1/2"
Collection of Yale University Art Gallery, The Edwin Austin Abbey Memorial Collection
Photograph: Yale University Art Gallery

Anonymous
Album of botanical studies
Japanese, Edo Period 1800-1850
Color and ink on paper, 10 1/2 x 7 x 1/2"
Collection of Julia Meech

Anonymous
Gafu [Collection of Prints] Part 1: Birds; Part 2: Insects and Fish
Japanese, n. d.
Ink on paper with string binding, 10 1/2 x 6 9/16 x 1/4"
Collection of the Ipswich Historical Society
#2903

Anonymous
Ink painting book
Japanese, Edo period, 19th century

Ink on rice paper with string binding, 7 1/4 x 10 1/4 x 3/8"
Collection of Pratt Institute Library

Anonymous
Printed White on Black
Japanese, n. d.
Handmade paper book, 7 x 10 1/2 x 3/8"
Collection of the Ipswich Historical Society
#1712
(Schafler Gallery only)

Anonymous
Shinkoku [New Patterns (from Kyoto)], n. d.
Handmade paper book, 10 13/16 x 7 13/16 x 7/16"
Collection of the Ipswich Historical Society
#1192
(Schafler Gallery only)

Basketry bowl
Native American (Pima), Arizona, first quarter 20th century
Plant fiber, 4 1/8 x 14 3/4" diam.
Collection of the Brooklyn Museum of Art, Gift of Pratt Institute,
#46.136.5

Basketry bowl
Native American, Southwest USA or central California, first quarter 20th century
Plant fiber, 4 1/4 x 11 7/16" diam.
Collection of the Brooklyn Museum of Art, Gift of Mrs. Frederic B. Pratt,
#37.186

Basket with lid
Native American, Aleutian Islands, first quarter

20th century
Plant fiber and wool, 7 1/4 x 6 1/8"diam.
Collection of the Brooklyn Museum of Art, Gift
of Frederic B. Pratt
#36.498a-b
Photograph: Brooklyn Museum of Art

Edwin H. Blashfield
Study for Mural in the Library of George Drexel.
1895-96
Photograph collage and paint on
wood, 18 7/8" diam.
Collection of Bayly Art Museum of the University
of Virginia, Gift of Mrs. Florence K. Sloane

Robert Blum
*Figure Studies: Head, Nude and Draped
Figure.* n. d.
Charcoal on artist board, 17 1/2 x 20 3/4"
Collection of Berea College, Berea, Kentucky
#140.D.12

Robert Blum
Illustrations in *Japonica,* a monograph by
Edwin Arnold. 1891
Ink drawing and watercolor reproductions,
9 13/16 x 7" (book)
Collection of the General Research Division, The
New York Public Library, Astor, Lenox and Tilden
Foundations
PRAT03

Robert Blum
Little Japanese Girl. n. d.
Watercolor on paper, 13 x 8"
Collection of Berea College, Berea, Kentucky,
#140.W.6

Robert Blum
Photograph of clay figurines for *The Vintage
Festival.* n. d.
Copy of original photograph, 8 x 10"
Courtesy of the Cincinnati Art Museum

Robert Blum
Two Standing Draped Figures. n. d.
Charcoal and chalk on artist board, 20 1/2 x 15"
Collection of Berea College, Berea, Kentucky
#140.D.10

Robert Blum
The Vintage Festival. n. d.

Photograph of mural, 2 5/8 x 12 7/8'
Courtesy of the Brooklyn Museum of Art

Bottle. c.1901-1905
Tiffany Studios
Corona, New York
"Favrile" glass, 3 x 1 3/4" diam.
Collection of the Brooklyn Museum of Art,
Bequest of Laura L. Barnes
#67.120.62

Will Bradley
When Hearts are Trump by Tom Hall (plate #52
from the Maitres de l'Affiche series), 1894
Lithograph, 9 3/4 x 7 7/8"
Courtesy of Park South Gallery, New York

Braun, Clément & Co.
Baptism of Our Lord by Perugino. c. 1890
Reproduction photograph, 5 1/2 x 9 3/8"
Collection of Pratt Institute Library

Braun, Clément & Co.
Dramatic Poetry by Puvis de Chavannes. c. 1890
Reproduction photograph, 15 1/2 x 9"
Collection of Pratt Institute Library
(Schafler Gallery only)

Braun, Clément & Co.
Dying Friar Sees St. Francis Carried into Heaven
by Giotto. c. 1890
Reproduction photograph, 9 3/4 x 7 3/4"
Collection of Pratt Institute Library

Braun, Clément & Co.
Persephone, Demeter & Iris from East Pediment
of the Parthenon by Phidias. c. 1890
Reproduction photograph, 8 1/2 x 11 3/8"
Collection of Pratt Institute Library
(Schafler Gallery only)

Braun, Clément & Co.
Tomb of Marguerite de Bourbon (detail). c. 1890
Reproduction photograph, 10 1/2 x 8 1/4"
Collection of Pratt Institute Library
(Schafler Gallery only)

Theodore E. Butler.
Brooklyn Bridge. 1900
Oil on canvas, 30 x 40"
Private collection
Photograph: R. H. Love Galleries, Chicago

Jules Cheret
La Loie Fuller. 1893
Color lithograph poster, 48 1/2 x 34"
Collection of Mark J. Weinbaum
(Schafler Gallery only)

John S. Clark, Mary Dana Hicks,
Walter S. Perry (authors)
The Prang Educational Company (publisher)
Illustrations by students of Dow at Pratt Institute,
in the *Teacher's Manual (Part IV) for The Prang
Elementary Course in Art Instruction.*
Books 7 and 8, Sixth Year, 1899
Ink drawing reproductions, various sizes
Collection of the Elmer Holmes Bobst Library,
New York University

Alvin Langdon Coburn
The Bridge, Ipswich. 1903
Photogravure, 7 9/16 x 5 7/8"
Courtesy of Gallery 292, New York

Alvin Langdon Coburn
The Dragon. n. d.
Photograph, 7 1/4 x 8 7/8"
Collection of Barbara Wright

Charles C. Curran
Wash Day. 1887-88
Oil on canvas, 54 x 30"
Courtesy Adelson Galleries

Arthur B. Davies
Mother and Child. 1896
Oil on canvas, 11 1/2 x 5 5/8"
Collection of the Utica Public Library,
Utica, New York

Arthur B. Davies
The Source. 1896.
Oil on canvas, 12 x 15"
Collection of the Frances Lehman Loeb Art
Center, Vassar College, Poughkeepsie, NY
(Schafler Gallery only)

Charles H. Davis
Grey Day Early Winter. 1892
Oil on canvas, 15 x 18"
Private collection

Arthur Dow with class at Pratt. 1899
Gelatin print, 3 1/2 x 4"
Collection of the Papers of Arthur Dow, Archives
of American Art, Smithsonian Institution

Arthur and Minnie Dow at Kasuga Shrine,
Nara. 1903
Cyanotype, 3 1/4 x 4 3/8"
Collection of the Ipswich Historical Society

Arthur Wesley Dow
Au Soir. 1888
Ink on paper, 5 1/4 x 8 7/8"
Collection of Barbara Wright

Arthur Wesley Dow
Bend of the River. 1895
Colored woodcut, 5 x 2 1/2"
Collection of the Ipswich Historical Society

Attributed to Arthur Wesley Dow
Burgundy Roses by the Artist as a Young Man.
c. 1884
Oil on canvas, 10 x 16"
Collection of Henry F. Kennedy
(Schafler Gallery only)

Arthur Wesley Dow (author)
J. M. Bowles, Boston (publisher)
Composition. 1899
Textbook, 7 x 14 x 1"
Collection of Pratt Institute Library

Dow and wife on elephant. n. d.
Cyanotype, 4 1/4 x 3 1/4"
Collection of the Ipswich Historical Society

Arthur Wesley Dow
The Dragon. n. d.
Cyanotype, 6 1/8 x 8 1/8"
Collection of Barbara Wright

Arthur Wesley Dow
Indian weaving baskets. n. d.
Cyanotype, 3 1/8 x 4 1/4"
Collection of the Ipswich Historical Society

Arthur Wesley Dow
Indian woman with pots and baskets. n. d.
Cyanotype, 4 1/4 x 3 1/4"
Collection of the Ipswich Historical Society

Arthur Wesley Dow
Ipswich Bridge. c.1895
Colored woodcut, 5 x 2 1/4"
Private collection

Arthur Wesley Dow
Ipswich Shanties. 1895
Colored woodcut, 5 x 2 1/2"
Collection of the Ipswich Historical Society

Arthur Wesley Dow
Little Venice. 1893-95
Three color woodcuts, each 4 7/8 x 2 1/8"
Collection of Barbara Wright

Arthur Wesley Dow (author)
"Painting with Wooden Blocks"
Illustrated article in *Modern Art,* Volume 4,
Summer 1896, pages 87-88.
Collection of Pratt Institute Library

Arthur Wesley Dow
Sketchbook #375. 1892
Pencil on paper with string binding,
8 1/2 x 4 1/2 x 3/4"
Collection of the Ipswich Historical Society

Arthur Wesley Dow
Turkey Shore. 1890
Oil on canvas, 17 3/4 x 31 5/8"
Collection of the First National Bank of Ipswich

Arthur Wesley Dow
View in Ipswich. 1895
Colored woodcut, 5 x 2 1/2"
Collection of the Ipswich Historical Society

Arthur Wesley Dow
Vista, Houses in Foreground. n. d.
Ink wash on paper, 15 x 16"
Collection of the Town of Ipswich Public Library

Arthur Wesley Dow
Printing blocks, n. d.
Wood, 2 1/4 x 5" and 10 x 7 1/2"
Collection of Barbara Wright

Frank Vincent DuMond
Christ and the Fishermen. 1891
Oil on canvas, 52 x 60"
Collection of N. Robert Cestone and
Steven V. DeLange
(Schafler Gallery only)

Frank Vincent DuMond
The Well. 1896
Oil on canvas, 15 1/2 x 19 1/2"
Collection of N. Robert Cestone

Frank Vincent DuMond
Woman at Window. 1901
Illustration for *Harper's,* 26 x 18 1/2"
Collection of N. Robert Cestone

Albrecht Dürer
Saint Anthony the Hermit. 1519
Engraving, 16 3/8 x 8"
Collection of the Brooklyn Museum of Art,
Gift of Mrs. Charles Pratt
#57.188-18

Emerson House, from Dow's album. n. d.
Photograph, 3 1/8 x 3"
Collection of Barbara Wright

Fruit cup. c. 1906-1912
Tiffany Studios
Corona, New York
"Favrile" glass, 3 5/8 x 3 3/4" diameter
Collection of the Brooklyn Museum of Art,
Bequest of Laura L. Barnes
#67.120.112

Eugène Grasset
Napoleon. 1894
Color lithograph poster, 27 1/4 x 19"
Collection of Mark J. Weinbaum

Ernest Haskell
Mrs. Fiske as Becky Sharp. 1899
Color lithograph poster, 22 x 15"
Print Collection, The Miriam and Ira D. Wallach
Division of Art, Prints and Photographs,
The New York Public Library, Astor, Lenox and
Tilden Foundations

Ernest Haskell
Portrait of Whistler. 1898
Platinotype reproduction of charcoal drawing,
14 x 20"
A. E. Gallatin Collection, Print Collection, The
Miriam and Ira D. Wallach Division of Art, Prints
and Photographs, The New York Public Library,
Astor, Lenox and Tilden Foundations
Photograph: The New York Public Library

Robert Henri
The Man Who Posed as Richelieu. 1898
Oil on canvas, 32 1/8 x 25 3/4"

Collection of the Brooklyn Museum of Art,
Gift of Roy Neuberger and exchange
#63.46
Photograph: Brooklyn Museum of Art

Robert Henri
On the East River. 1900-02
Oil on canvas, 28 x 32"
Collection of the Mead Art Museum,
Amherst College, Gift of Mr. and Mrs. Rogin
Photograph: Mead Art Museum

Ando Hiroshige
*Narumi Station, Travelers Passing a Row of Fabric
Shops,* from the *53 Stations of the Tokaido* series.
c. 1833-34
Woodblock color print, 8 7/8 x 14"
Private collection

Ando Hiroshige
Sakanoshita: The Throwing Away the Brush Peak,
from the *53 Stations of the Tokaido series.*
Edo period, 1834.
Woodblock color print, 8 7/8 x 9 13/16"
Collection of the Brooklyn Museum of Art,
Gift of Frederic Pratt
 #42.72
(Schafler Gallery only)

Katsushika Hokusai
Eijiri Station, Province of Suruga, from the *36
Views of Mt. Fuji* series. 1832
Woodblock color print, 9 9/16 x 14 1/4"
Collection of the Brooklyn Museum of Art,
Gift of Frederic B. Pratt
#42.74
(Jensen Fine Arts only)

Katsushika Hokusai
*Hokusai Gafu Johen(zen) [A Collection of Prints
by Hokusai],* Volume 1. n. d.
Handmade paper book, 9 x 6 1/4 x 5/16"
Collection of the Ipswich Historical Society
#1504
(Schafler Gallery only)

Gertrude Käsebier
Arthur B. Davies. 1907
Platinum print, 7 1/4 x 5 1/8"
Collection of the Records of Ferargil Gallery,
Archives of American Art, Smithsonian Institution

Gertrude Käsebier
Arthur Wesley Dow. 1896-98
Platinum print, 6 3/4 x 4 3/4"
Collection of Barbara Wright

Gertrude Käsebier
Kills Close to the Lodge. 1898
Platinum print, 7 15/16 x 6"
Collection of Pratt Institute Library

Gertrude Käsebier
Lone Bear. 1898
Platinum print, 8 x 6 5/8"
Collection of Pratt Institute Library
(Schafler Gallery only)

Gertrude Käsebier
Photograph of Jacob Riis in *World's Work.*
1900-01
Platinum print reproduction, 7 1/8 x 5 1/4"
Collection of General Research Division,
The New York Public Library, Astor, Lenox and
Tilden Foundations
#PRAT04

Gertrude Käsebier
Portrait Study. 1899
Photogravure, 6 1/8 x 4 3/4"
Courtesy of Gallery 292, New York

John LaFarge
Angel Serving with Servants of God. 1894
Graphite on paper, 16 3/8 x 8"
Collection of the Brooklyn Museum of Art,
Gift of George D. Pratt
#13.1063

John LaFarge
The Ascension. 1885-86
Sepia on paper, 20 3/4 x 11 3/4"
Collection of Mount St. Mary's College Library,
Special Collections, Emmitsburg, Maryland

John LaFarge
Sitting Siva Dance. 1894
Gouache and graphite on cardboard,
13 13/4 x 21 13/16"
Collection of the Carnegie Museum of Art,
Pittsburgh, Pennsylvania; Museum Purchase 1917
Photograph: Carnegie Museum of Art

John LaFarge
Waterfall of Urami-No-Taki. c. 1886
Watercolor on paper, 10 1/2 x 15 1/2"
Collection of the Addison Gallery of American
Art, Phillips Academy, Andover, Massachusetts
#1984.21
Photograph: Addison Gallery of American Art

Lamp. c. 1910
Tiffany Studios
Corona, New York
Glass and bronze, 13 x 7 1/16" diam. (shade)
Collection of the Brooklyn Museum of Art,
Bequest of Laura L. Barnes
#67.120.56

Large basket
Native American (Skikomish), Washington,
Puget Sound, first quarter 20th century
Hemp, 12 3/4 x 14 3/4" diameter
Collection of the Brooklyn Museum of Art,
Gift of Pratt Institute
#46.136-11

Tachiban Morikuni
Fujimura Zenuemon (carver)
Nishimura & Genroku of Edo (publisher)
Unpitsu Soga (ge) [Rough Pictures of Brush Strokes],
Volume 2 or 3. 1749
Handmade paper book, 7 x 10 1/2 x 3/8"
Collection of the Ipswich Historical Society
#1712
(Schafler Gallery only)

Harue (or Shunko) Odagiri.
Narumikata (5 volumes with a 1983 Introduction).
1881
Ink sketches and printed text in handmade paper
book with string binding, 9 1/8 x 6 1/4"
Collection of Pratt Institute Library
(Schafler Gallery only)

Edward Penfield
Cover of *Harper's.* February 1894
Lithograph, 15 13/16 x 11 7/8"
Collection of Mark J. Weinbaum

Edward Penfield
Cover of *Harper's.* March 1894
Lithograph, 15 13/16 x 11 7/8"
Collection of the Brooklyn Museum of Art,

Dick S. Ramsay Fund
#53.167-8

Edith Prellwitz
The Rose. c. 1896-99
Oil on canvas, 25 x 18"
Collection of Sam Prellwitz,
Pittsburgh, Pennsylvania

Henry Prellwitz
Dante and Virgil. c. 1897
Oil on canvas, 30 1/2 x 48"
Collection of Ronald G. Pisano, Inc.

Howard Pyle
Boy Running. 1891
Ink on paper, 9 x 4"
Collection of the Society of Illustrators
Museum of American Illustration, New York

Howard Pyle
King Leodegrance. 1902
Ink on paper, 9 3/16" x 6 5/16"
Collection of Walt Reed

Louis Read
The Sun. 1895
Color lithograph poster, 43 1/2 x 24"
Collection of Mark J. Weinbaum

Robert Reid
Summer Breezes. c. 1896
Oil on canvas, 25 x 30"
Courtesy of the Reading Public Museum,
Reading, Pennsylvania

Guy Orlando Rose
July Afternoon. 1897
Oil on canvas, 14 3/4 x 29 3/4"
Collection of Roy C. Rose

Sake bottle and cup
Japanese, 18th century
Lacquer, 8 3/4 x 4" diameter (bottle);
2 1/4 x 3 1/2" diameter (cup)
Collection of the Brooklyn Museum of Art,
Gift of Mrs. Frederic B. Pratt,
#30.1463-64
Photograph: Brooklyn Museum of Art
(Schafler Gallery only)

Pamela Colman Smith
The Land of Heart's Desire. Triptych illustrating a
play of the same name by William Butler Yeats.
c. 1898
Hand-colored process print, 11 3/4 x 20 1/8"
Collection of Melinda Boyd Parsons

Sword guard
Japanese, 19th century
Iron, 3 3/8 x 3 x 1/4"
Collection of the Brooklyn Museum of Art,
Gift of Mrs. Frederic B. Pratt
#29.1606.2

Textile fragment
Coptic, c. 8th century
Linen, 6 x 13 1/4"
Collection of Pratt Institute

Textile fragment
Italian, 17th century
Silk cut and uncut velvet, 8 1/4 x 10"
Collection of the Brooklyn Museum of Art,
Gift of Pratt Institute
#34.168
Photograph: Brooklyn Museum of Art

Textile fragment
Spanish, c. 18th century
Polychrome silk brocade, gold silk and metallic
ribbon, 21 x 19 1/2"
Collection of the Brooklyn Museum of Art,
Gift of Pratt Institute
#32.249

Louis Comfort Tiffany Vase, 1900
Tiffany Studios
Corona, New York
"Favrile" glass, 4 5/8 x 3 1/4" diam.
Collection of the Brooklyn Museum of Art,
Gift of Charles W. Gould
#14.739.3
Photograph: Brooklyn Museum of Art

Henri de Toulouse-Lautrec
Le Divan japonais. 1893
Color lithograph poster, 31 x 24"
Collection of Mark Weinbaum
(Jensen Fine Arts only)

Vase. c. 1899-1905
Grueby Faience Company
Boston, Massachusetts
Glazed earthenware, 9 x 2 3/8" diam. (base)
Collection of the Brooklyn Museum of Art,
Gift from the Collection of Edward A. Behr
#61.113
Photograph: Brooklyn Museum of Art

William Thompson Walters
D. Appleton, New York (publisher)
*Oriental Ceramic Art; illustrated by examples from
the collection of W. T. Walters, text and notes by S. W.
Bushell.* 1897
Folio, 23 x 17 1/8"
Collection of the Brooklyn Museum of Art
Libraries, Gift of Carll H. de Silver
NK 4163 W17 Sect. 1

Max Weber
Abstract Tassels. 1914
Gouache on paper, 23 3/8 x 11 1/2"
Courtesy of Forum Gallery, New York

Clarence White
The Readers. 1897
Photograph, 7 7/16 x 4 1/8"
Collection of The Licking County Historical
Society, Newark, Ohio

Clarence White
Telegraph Poles. 1898
Photogravure, 7 7/16 x 4 1/8"
Courtesy of Gallery 292, New York

Grace Young (decorator)
Vase. 1899
Rookwood Pottery
Cincinnati, Ohio
Glazed earthenware, 15 1/2 x 6 x 6"
Collection of the Brooklyn Museum of Art,
Gift of Mr. and Mrs. Jay Lewis
#84.176.4

Pratt
and Its
Gallery
THE ARTS & CRAFTS YEARS